Sketching Landscapes

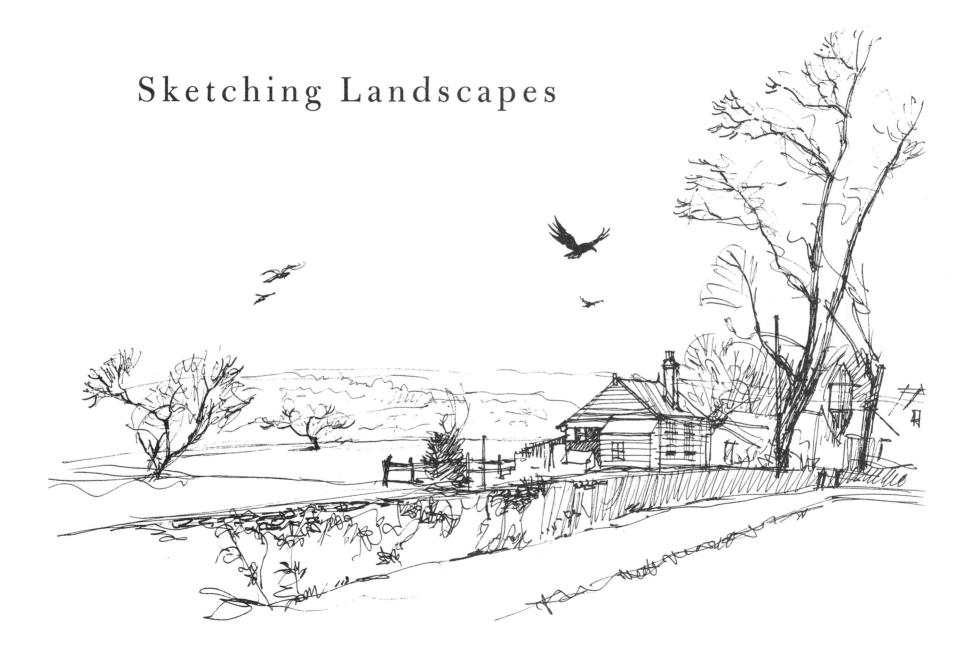

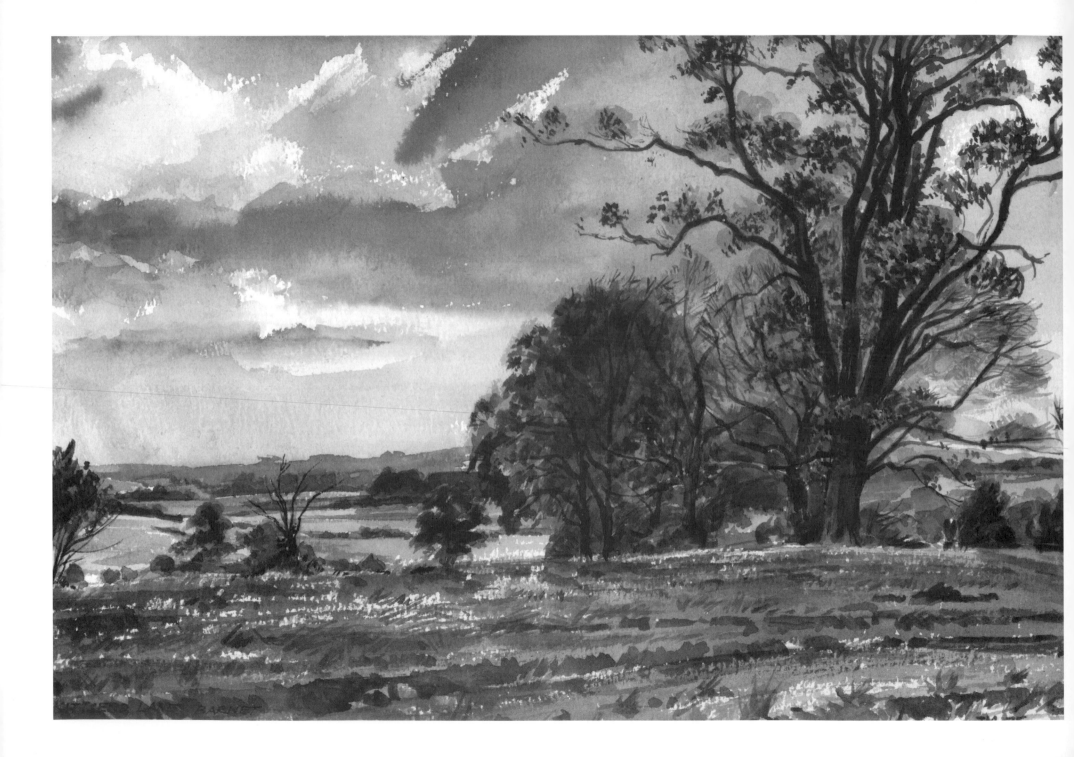

Sketching Landscapes

JOHN MARSH

CASSELL

Cassell
Wellington House, 125 Strand
London WC2R 0BB
www.cassell.co.uk

Distributed in the United States by
Sterling Publishing Co. Inc.
387 Park Avenue South
New York NY 10016-8810

British Library Cataloguing-in-Publication Data
A catalogue record for this book is available from the British Library

ISBN 0-304-35118-0

Printed and bound in Great Britain by
Hillman Printers (Frome) Ltd, Somerset

Contents

Keeping a sketchbook

As soon as I open one of my sketchbooks memories return of time spent in concentrated looking, contemplating and experiencing. I can feel the heat, cold, discomfort, excitement, atmosphere; even recall some dialogue, sounds, or reactions to my surroundings, thanks to scribbled notes in the margins. Time passes so quickly and my pile of books has grown, but sorting through them for this book has been reassuring justification for my obsessive practice of always keeping one on the go.

No artist's work will improve without observation, experimentation, risking failure. It's a personal quest which each individual has to undertake in their own way. A lot of this can be explored in a sketchbook and I would like to encourage you to begin one straight away if you haven't already done so. Only you can get the ball rolling. Start by keeping it like a private and personal diary until you gain confidence in your abilities. Other people's comments on your efforts can be inhibiting even if well meaning.

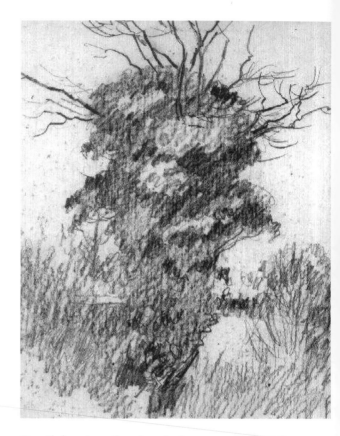

Pencil drawing of an ivy-clad tree stump. Here the foliage has been indicated by simple light and dark areas of tonal 'shading' with no attempt to show details of individual leaves.

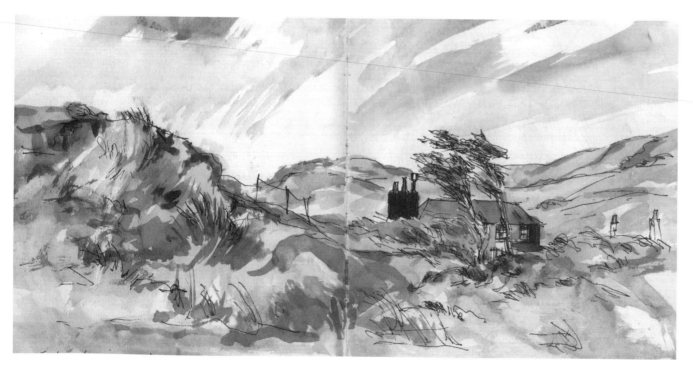

Pen and watercolour wash sketch on a windy morning, drawn across two pages of a sketchbook. In such conditions it's a good a good idea to carry paper clips or elastic bands in case you need to hold your pages down.

Your personality will play a large part in the selection of your book; its size, shape, binding and paper. Many other factors come into play, and that's really what this book is all about.

I aim to share with you some practical experience developed through many years of pursuing this delightful activity and hope that you get as much joy from it as I do myself.

A visual diary

An extension of the use of a sketchbook may be to combine drawings, written notes, photos, collected tickets, cuttings, postcards, pressed flowers, feathers, seeds, scraps of fabric, colour samples; in short anything which can be stuck in a book to record your experiences or be useful reference material. Some sketches can be done on the spot, but if you train your visual memory you can draw things later from your 'memory banks'. The more you draw from observation the better your visual recall will become.

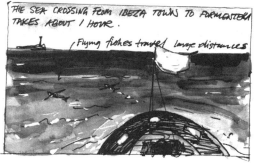

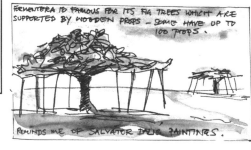

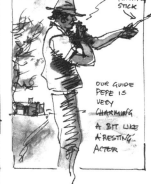

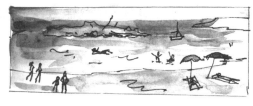

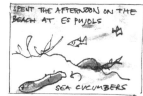

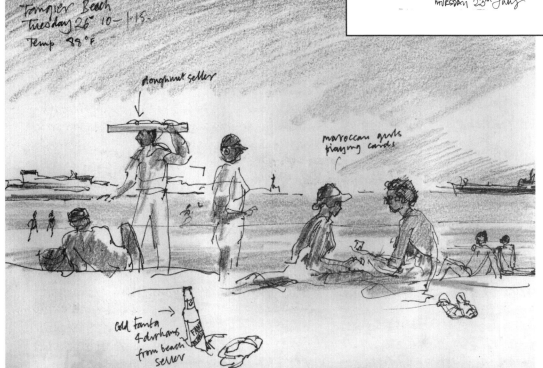

Visual research

For the serious student or practitioner of art and design, visual research is a way of collecting relevant information in relation to a set of needs. An illustration may need to include historically accurate details, for example, so a visit to a museum or library equipped with a trusty sketchbook might be an obvious starting point.

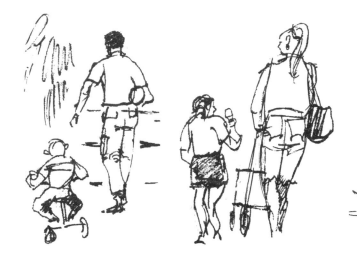

Pencil study of a tree trunk. Interesting subjects are all around us. The act of focusing attention and attempting a sketch will help to reveal them once we start making marks on paper. Artists call this 'seeing through drawing'.

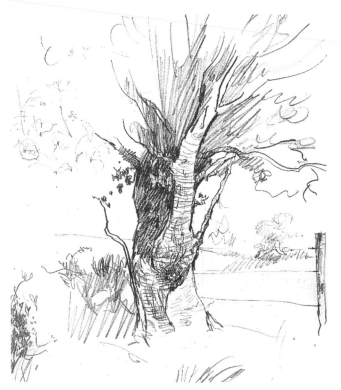

Rapid pen sketches trying to capture gestures rather than detail. Drawing directly with a pen without preliminary pencil work forces you to sum up a situation in the simplest terms. If a line is wrong you have to 'overdraw' the first mark because it is impossible to rub out. This is a

good way of developing your personal 'visual handwriting'. Here a fibre-tipped pen, which you don't have to keep dipping, has assisted in the speed of sketching these ducks by the river. Some artists use a fountain pen or a ball-point for the same reason.

Designers frequently collect together sources of inspiration to assist in the generation of new ideas. For the landscape artist the sketchbook can be a way of collecting visual information which may later be put together in more finished compositions. Figures, animals, plants or buildings can be introduced to enliven a painting done indoors in studio conditions.

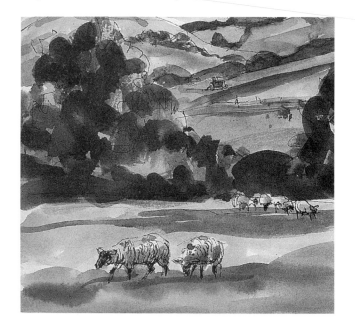

Pen line and wash. Animals keep on the move but you have to make a start drawing them. Try to retain a visual memory and hope that they will oblige you with a fresh chance to finish your sketch at a later stage; they tend to resume the same pose every so often. A camera will help if you run short of time.

Basic tools

A bewildering variety of drawing implements is now available but it is best to start with the most basic ones and get to know what effects they can produce. Sketching outdoors requires that you travel light, carrying only a small selection of tried and trusted tools and equipment.

Pencils, crayons, pastels and charcoal

To some extent your choice of these will influence your approach, direct what you look at and the information you are able to put down in a sketch. In general hard (H) grade pencils or sharp pointed implements such as pens, drawn on smooth paper surfaces make it possible to record fine details, whereas soft (B) grade pencils, charcoal, crayons or pastels drawn on to rough-surfaced papers are best for broad tonal impressions – such as the sketch top right.

Soft pencils will become blunt quickly so it is important to have a craft knife or a sharpener handy. Another vital tool is a kneadable eraser which can be moulded to a point to help clean up, lighten areas, or pick out highlights without smudging. You can blend tones with your fingers or specially made rolled cardboard torchons. It is probably a good idea to spray such drawings with fixative if you don't want a messy sketchbook.

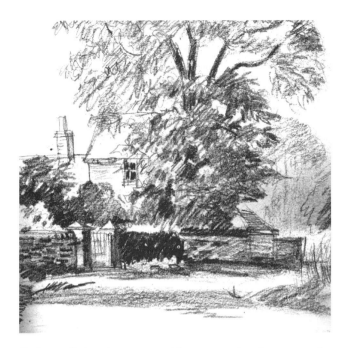

Soft pencil drawing on cartridge paper showing general distribution of light and dark tones.

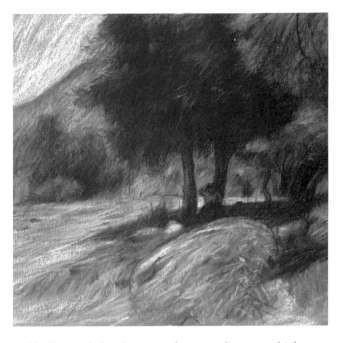

Chalk pastel sketch on rough textured paper, which enables a quick, bold treatment.

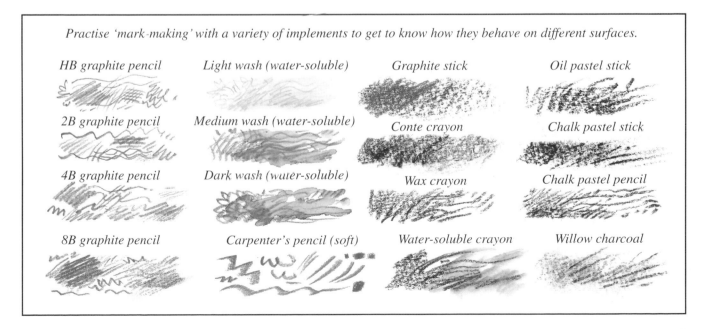

Practise 'mark-making' with a variety of implements to get to know how they behave on different surfaces.

HB graphite pencil	*Light wash (water-soluble)*	*Graphite stick*	*Oil pastel stick*
2B graphite pencil	*Medium wash (water-soluble)*	*Conte crayon*	*Chalk pastel stick*
4B graphite pencil	*Dark wash (water-soluble)*	*Wax crayon*	*Chalk pastel pencil*
8B graphite pencil	*Carpenter's pencil (soft)*	*Water-soluble crayon*	*Willow charcoal*

Felt tips, fibre tips

With so many new products on the market it is worthwhile experimenting to find which felt tips or fibre tips suit your requirements. Some are water resistant, which is important to test if you intend to put a wash over them. Others bleed through the paper, appearing on the reverse side of the sheet or, worse still, going through several layers. The pigments used may also fade after a while if exposed to daylight. However, they are cheap, portable and a great asset for quick sketching.

Rollerballs, brushpens, fine liners, technical and calligraphy pens all provide the artist with different qualities of line.

Pens, ink and brushes

More traditional dip pens are capable of great flexibility and variety of marks. Usually they are dipped into inks which are either 'fixed' or waterproof when dry, or unfixed, which are not, but have the qualities of making very good washes without clogging up pens or brushes.

Reed pens, bamboo pens and quills can be cut, sharpened and customized to suit your needs.

Steel nibs, which can be fitted into holders, come in a variety of widths and can give varied line widths depending on the pressure you apply.

Fountain pens for sketching are useful but must usually be used with unfixed ink.

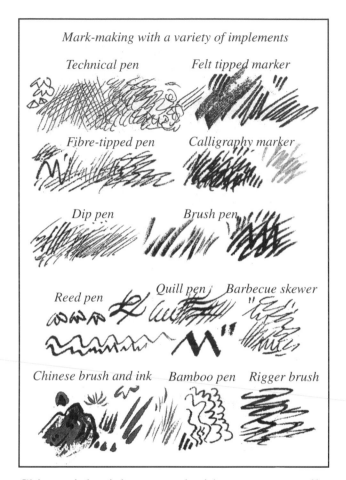

Mark-making with a variety of implements

Technical pen

Felt tipped marker

Fibre-tipped pen

Calligraphy marker

Dip pen

Brush pen

Reed pen

Quill pen

Barbecue skewer

Chinese brush and ink

Bamboo pen

Rigger brush

Chinese ink sticks, ground with water on small stone pallets, can be modified in strength from the palest to richest blacks depending on the fineness of the grinding. In conjunction with Chinese brushes these enable wonderfully expressive effects.

Sable and synthetic hair brushes are also available in a wide variety sizes and forms. A 'rigger', a brush with long hair used by nautical painters to draw in the fine lines of rigging, can be almost like a pencil to draw with.

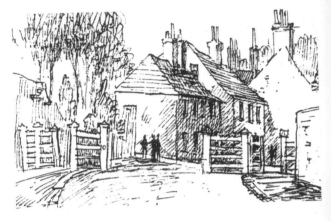

Pen sketch on smooth paper. Tones have to be made by cross-hatched lines.

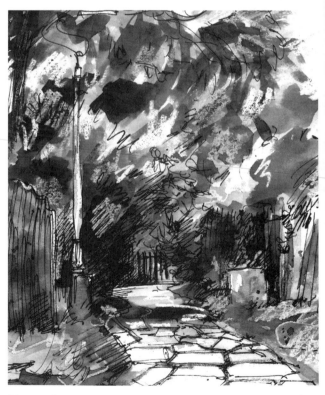

Line and wash sketch on watercolour paper. Begun with a water-resistant fibre-tipped pen, the tonal ink washes were applied afterwards with a sable brush.

Paper surfaces

There is a wide range of sketchbooks to choose from, ranging from low-cost cartridge pads to expensive, hand-made and bound watercolour books. You can, of course, use a drawing board and individual sheets of paper and vary the surfaces to suit each situation and purpose.

In general there are three types of paper surface:
- smooth or 'hot pressed' (mechanically pressed through hot rollers) which is suitable for fine detail and pen work;
- semi-rough or 'not pressed' which will suit most purposes;
- rough and textured papers which suit broader treatments.

Other important factors are the thickness or weight of the paper and its absorbency, which will affect its suitability for wash treatments if you wish to use them. You are generally safe with a sketchbook designated for watercolour, or if you buy heavier weight papers. Cheaper lightweight papers need to be 'stretched' on a drawing board as they tend to buckle when water is applied to them.

To stretch paper, wet the sheet thoroughly so that it goes floppy and attach it firmly to a board with brown gumstrip parcel tape around all the edges. When the paper dries it should stretch taut again and not buckle too much when water-colour washes are applied.

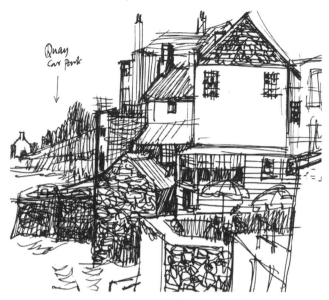

Pen sketch on smooth hot pressed paper. Ideal for quick line drawing in pen or harder grade pencils.

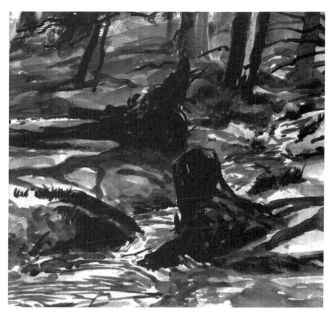

Brush drawing on semi-rough watercolour paper without preliminary pencil work.

Pencil on inexpensive cartridge paper. The smooth surface is ideal for general drawing and detailed work.

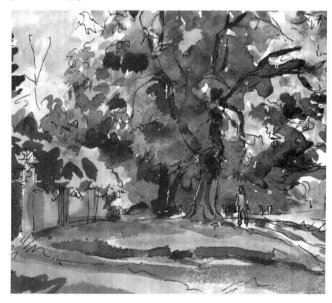

Pen line and wash sketch on watercolour paper. A pen draws the linework first; loose washes are then applied.

Subject matter

It is tempting to go in search of great imposing vistas to sketch in the manner of the landscapes displayed in national galleries. The trouble is that this could involve long journeys out of your home territory, crowds of sightseers and eventual frustration at your failure to do justice to the scene.

Often really worthwhile subjects are right under our noses waiting to be discovered. An old tree or a broken gate could be much more manageable to start with. Even with the most mundane of subjects, other qualities somehow seem to emerge as we get into looking closely and trying to represent what we see. Time spent in looking before drawing is seldom wasted.

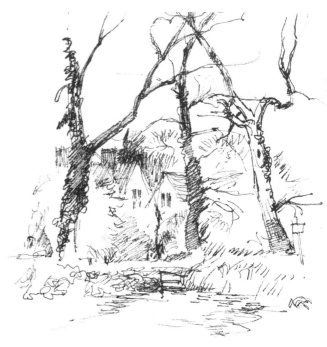

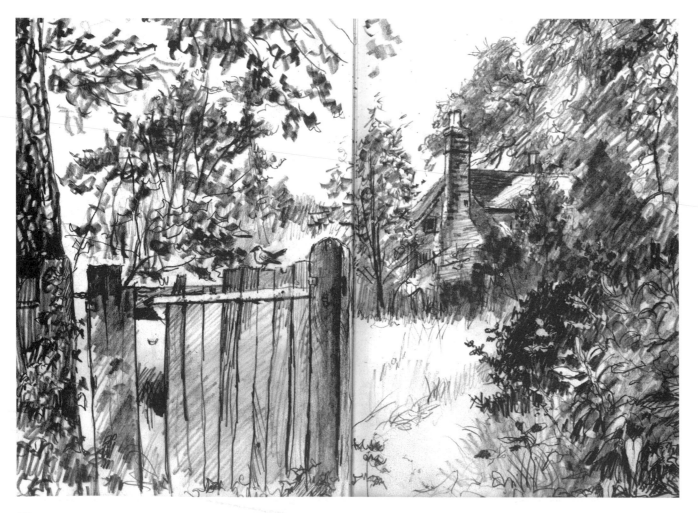

In the scene above, I liked the way the three trees seemed to lean towards each other as if in conversation.

Everyday subjects can become more interesting as you begin to draw them. Imperfections like the broken fence of this derelict cottage made me want to do this pencil sketch. The bird obligingly perched on the fence just long enough to be included. A short time afterwards the site was redeveloped and the garden smartened up. The landscape is in a constant state of change and a drawing can be a unique historical record.

Drawing shouldn't be a tedious activity; if you get bored just leave out things you don't find interesting. Bring in other elements you want to include or move them about to add to your composition – drawing should be a reflection of your personality.

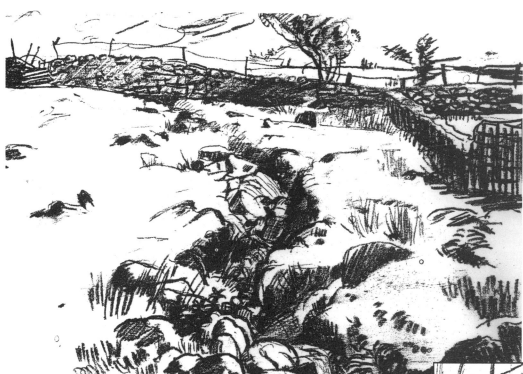

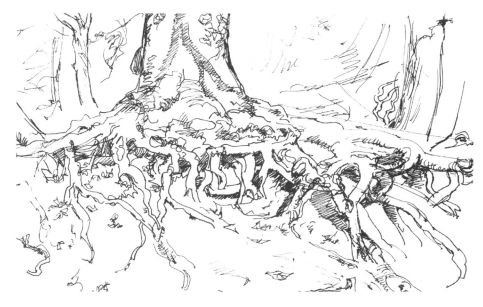

Pen sketch on smooth cartridge paper which began with a study of exposed tree roots. Subjects like this are good practice and readily available if you seek them out.

A simple subject: the path of a small stream in the corner of a field. It was drawn on to smooth cartridge paper with charcoal pencils, which can be sharpened to give a precise black line or smudged to give broader areas of tone.

Try looking for arrangements of light and dark tones which you can see more easily by squinting at your subject through half-closed eyes. Don't be afraid to leave white space in your drawing. The balance of positive and negative areas brings vitality to a composition. Cut a small window out of a piece of card to act as a viewfinder if you have problems in selecting what to focus on.

The sketch on the right was drawn with a soft (3B) graphite pencil on smooth cartridge paper. This was once the entrance to an old country mansion and the tonal arrangements and rhythms of the branches interested me. A few months later the ball had fallen off its plinth and work begun to convert the house into luxury apartments.

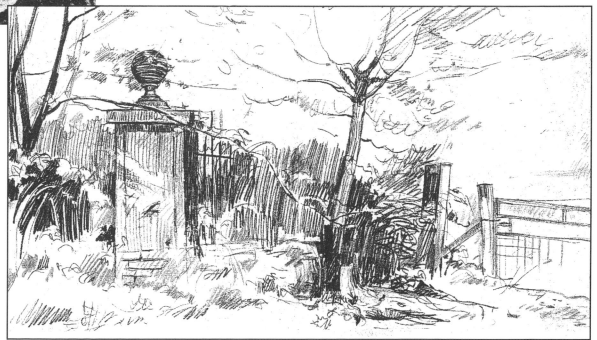

Simple perspective

As you progress with the art of drawing a sense of perspective becomes more instinctive but initially creating a sense of distance can be a stumbling block and rather off-putting. Creating an illusion of depth and recession is achieved in landscape sketching by establishing a contrast between foreground, middle ground and distance. Our judgement of distance is prompted by various visual clues which could be represented in a sketch.

Our eye level establishes a horizon which is apparent when we look out to sea, but when we look at a landscape it is usually less obvious.

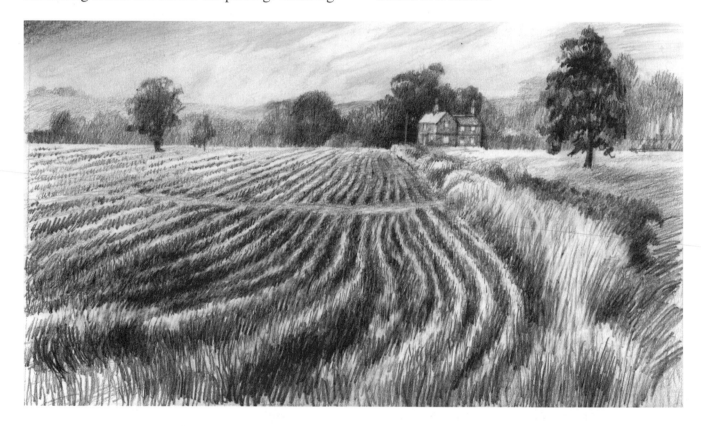

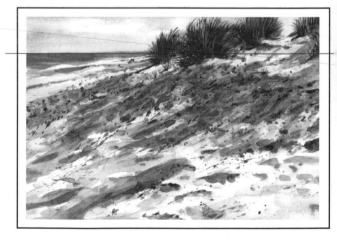

Details appear larger and more distinct in the foreground and the further away things are, the fainter and less defined they become. This effect, termed 'aerial perspective', can be usefully emphasized by making a distinct tonal contrast between the foreground and background layers of a landscape drawing.

Other helpful visual clues include overlapping areas, forms and contours, which define whether one thing is in front of another, and making the intervals between similar sized elements such as furrows on ploughed fields or ripples on water appear to diminish in size as they recede in the distance.

Where we position the horizon line on a page creates a subdivision between the areas of land and sky. Dynamic compositions can be achieved by allowing one or the other to dominate, rather than making everything symmetrical.

Your viewpoint should reflect the focus of your interests. If, for example, you wish to make a feature of the sky or look down on a scene, make the horizon lower down on your page.

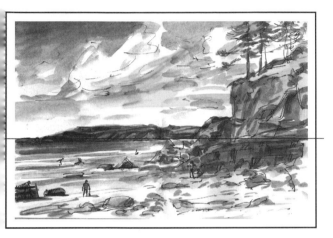

If you are more interested in the foreground make the horizon higher up.

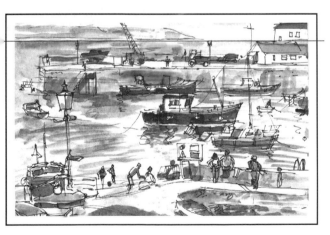

Once the eye level has been established in a sketch, all structures or elements in the landscape have to be drawn in relationship to it if we wish them to be 'in perspective'.

ONE POINT PERSPECTIVE

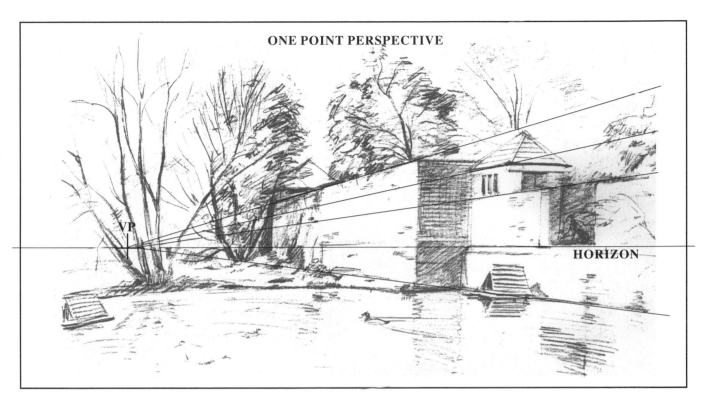

VP

HORIZON

Generally all receding parallel lines above your eye level appear to slant down towards the horizon and those below your eye level appear to travel upward. These converge on a point commonly known as a vanishing point (**VP**). '**One point perspective**' as illustrated above, is a term used to describe this type of viewpoint when there may be only one obvious vanishing point.

As an experiment, try securing some tracing paper over a photograph of some buildings and, using a ruler, trace lines which seem to converge to see where they intersect. From this you can deduce the camera level and the point at which the lens was focused.

TWO POINT PERSPECTIVE

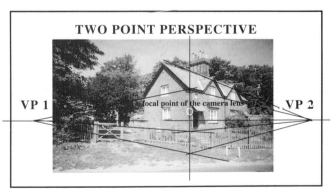

VP 1 focal point of the camera lens VP 2

When you face a building corner-on, with its sides receding away acutely on either side, there will be two sets of vanishing points, one to the left and the other to the right. This is commonly known as '**two point perspective**'.

Tones and shapes

The forms and textures of the landscape are revealed to us by light; but since this varies throughout the day and is modified by weather conditions, we are frequently struggling to capture fleeting effects.

Spend time studying how light falling on objects or the landscape affects a view – shadows cast in strong sunlight can give us hard-edged shapes, whereas more diffused lighting will be soft and atmospheric. Exploit the contrasts between light and dark areas in your drawing and indicate any big shapes first before getting involved in any detail.

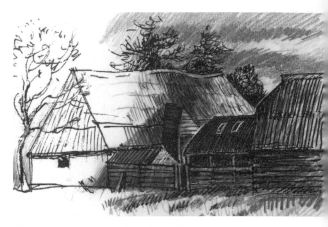

'Form' is a term used to describe the visual appearance and shape of something. Methods of representing form can be by the use of line and 'tones' (a range of values from light to dark). We can help to create an impression of solidity by adding tones, as in the part-completed demonstration above.

Techniques of 'modelling' using tones depend on the medium you choose. Soft media, such as pastel, charcoal, crayon or graphite, as shown on the left, enable you to lay down large areas of tonal shading. With a hard pen, however, you have to render tones by cross-hatched lines or stippling, as shown below.

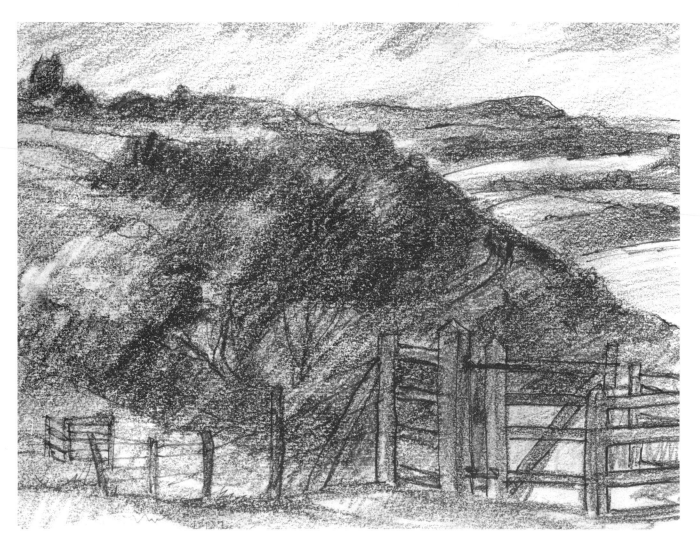

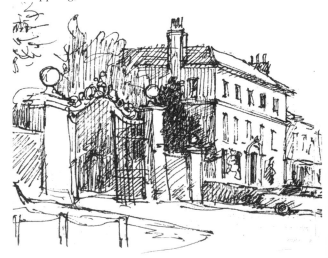

Skies and clouds

When there are no clouds in the sky it can be represented by a gentle gradation of tone; palest near the horizon and darkening towards the top. The appearance of clouds, however, is greatly influenced by the direction and elevation of the sun or moon. They are usually on the move so we have to work rapidly in appropriate media in order to capture the transient effects.

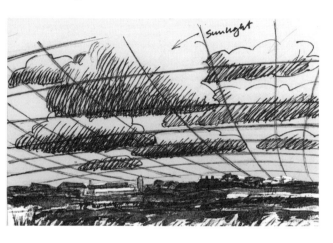

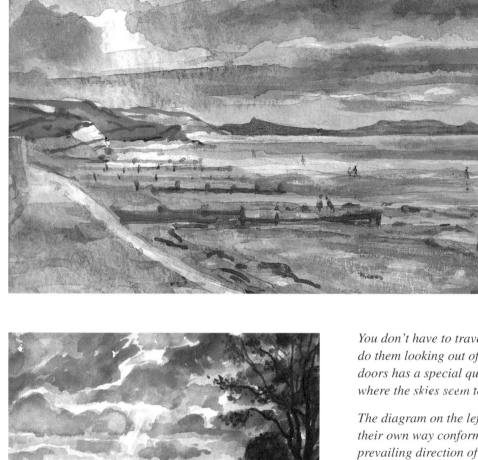

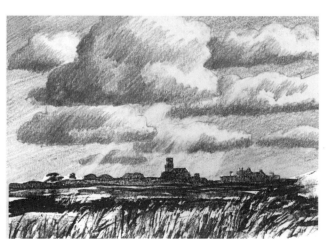

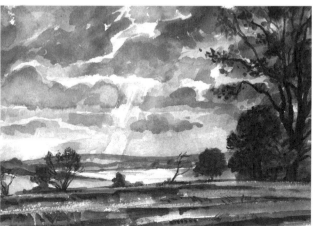

You don't have to travel to do sky studies. It's possible to do them looking out of a window, although being out of doors has a special quality, especially in flat country where the skies seem to dominate the landscape.

The diagram on the left attempts to show how clouds in their own way conform to perspective, and how the prevailing direction of the sun can light some areas whilst throwing other parts into shadow.

Small 'on-the-spot' sketches such as these try to capture the effects of rapidly moving clouds and contrasting lighting conditions. Some are done with soft pencils and others make use of directly applied watercolour washes.

Mountains and hills

From a high viewpoint you are able to watch the interplay of light crossing the landscape and revealing the basic topological structures below. Buildings, roads, rivers, lakes, hedgerows and trees are all part of the rich vocabulary of forms which can be included in our sketches.

It is helpful for our sense of tranquillity, self-importance and relativity to see small figures and cars dwarfed within expanses of space. Whether looking down from a height or up towards a mountain it gives us an impression of our own fragile and transitory nature.

The crayon sketch below was done across two pages of a sketchbook like using a wide-angled lens on a camera. Gliders were catching the thermals off the Downs in afternoon sunshine. It is fun to include figures, if they turn up, to add a feeling of scale and human interest.

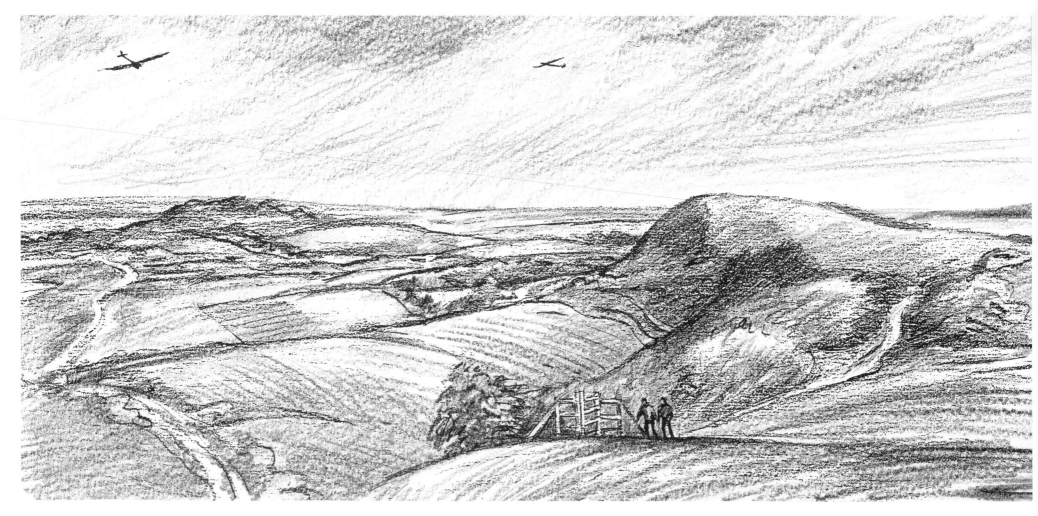

18

Water

In its many forms water plays a vital part in shaping the landscape and is a great subject for study. After rain the glistening reflections in puddles or on road surfaces can totally transform and enliven a foreground. Reflections are not simply a reverse image of a subject but can reveal its underside. They usually appear lighter than dark objects being reflected and darker than light objects.

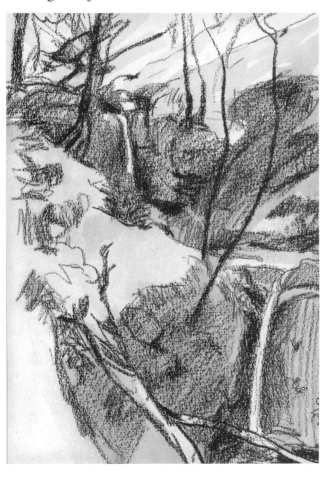

It is rare to get a perfect mirrored surface and usually some disturbance distorts the reflection, presenting the artist with a challenge to render the moving patterns produced. Practise using various tools to capture these, for example a rigger brush or a calligraphy pen.

Rapidly moving or agitated water has to be suggested since we can't draw its detail without freezing its motion. The charcoal pencil sketch on the left traces the path of a stream down through some rocks. It was an exercise in leaving things out and was influenced by the book on Chinese painting which I was reading that day.

Rigger brush marks *Calligraphy pen marks*

Rocks and cliffs

Geological formations offer good opportunities for study and lend themselves to rendering with most media. It is awe-inspiring to contemplate the massive forces and upheavals which have taken place to generate such forms.

The rhythmic layering of sedimentary rocks, rich textures or smooth worn surfaces present qualities which provide interesting subject matter. Changes of light throughout the day can also reveal different aspects while we sketch.

I like to observe the way people come and go like actors against an enduring backdrop. Some have been included in the pen and crayon sketch below to give a sense of scale and contrast against the sea-hewn rock formations.

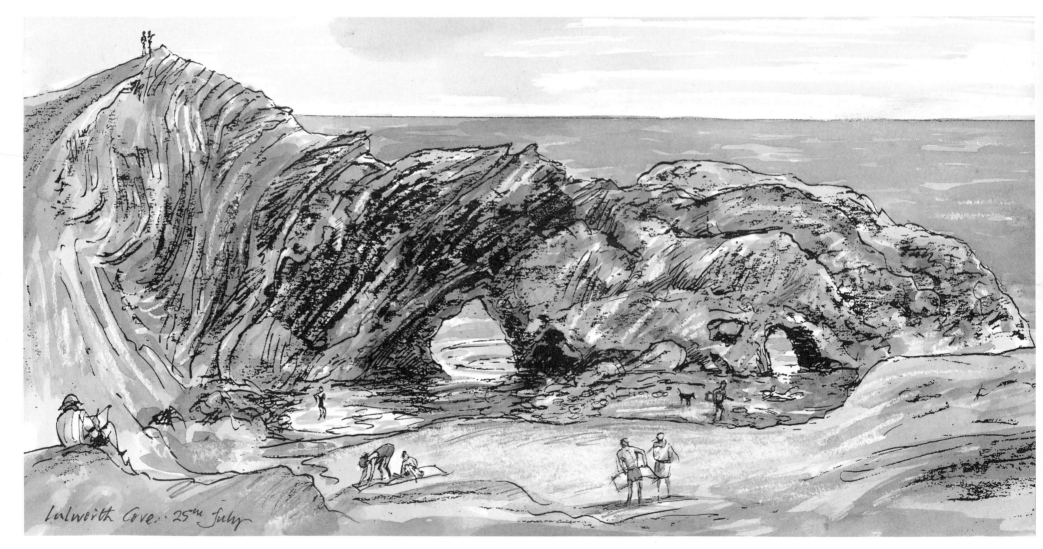

Lulworth Cove. 25th July

Trees

All trees have definite structures which can best be seen during winter, before they are obscured with masses of leaves. Apart from each species having its own distinctive shape they acquire a character shaped by age and environment. Studies of bare trees enable us to observe bark textures and rhythms of growth.

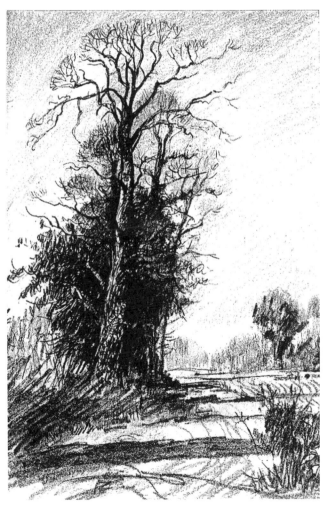

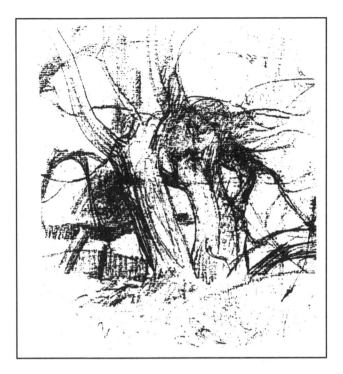

Sketches with pen or pencil should attempt to simplify detail and emphasize these qualities, starting with the major trunk and branches before tapering off towards a suggestion of the finer twigs.

Even when clothed in foliage it is important to visualize the underlying structure of a tree in order to draw or paint it convincingly. Look for the main massing of leaves and distribution of areas of shadow, retaining some patches of light which break through the cover and emphasize branches where they stand out against foliage or the sky. Rendering leaf textures requires a form of visual shorthand which you develop with practice. It is good to simplify where possible.

I find it beautiful to consider elements in the landscape having relationships and spiritual qualities. An ancient book on Chinese painting refers to 'old trees with grave dignity and an air of compassion, leading by the hand modest and retiring young trees'. Sketching outdoors can become a bit like meditation, and very uplifting providing you can overcome some of the occasional discomforts.

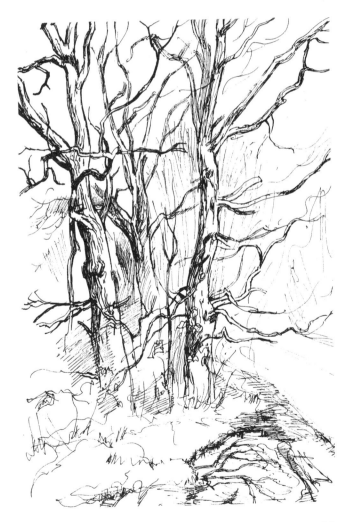

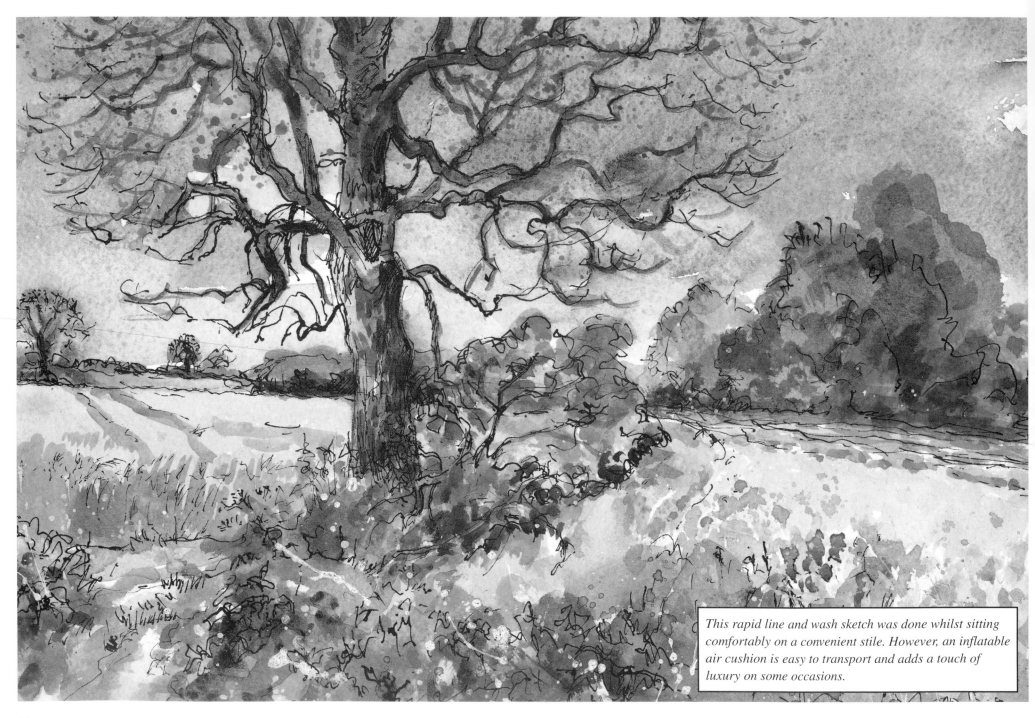

This rapid line and wash sketch was done whilst sitting comfortably on a convenient stile. However, an inflatable air cushion is easy to transport and adds a touch of luxury on some occasions.

Cottages and villages

Much of the regional character of our landscape is the result of buildings constructed from local materials, using traditional architecture. The pen sketch on the right is a shorthand note of the basic soft organic shapes of timber-framed cottages against contrasting tree forms.

Frequently, modernization of buildings in towns and villages smartens up their fronts but leaves the backs or rooflines comparatively untouched. It's possible to find some interesting subjects behind the facades: abandoned stables, sheds or relics of the past, like the old pump in the wash drawing below.

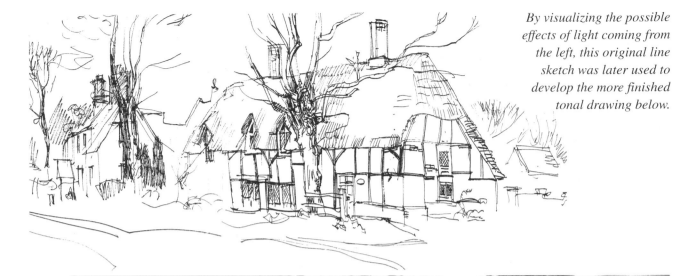

By visualizing the possible effects of light coming from the left, this original line sketch was later used to develop the more finished tonal drawing below.

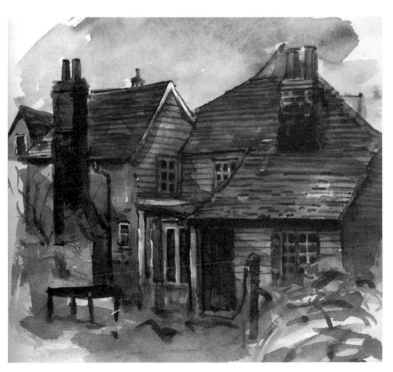

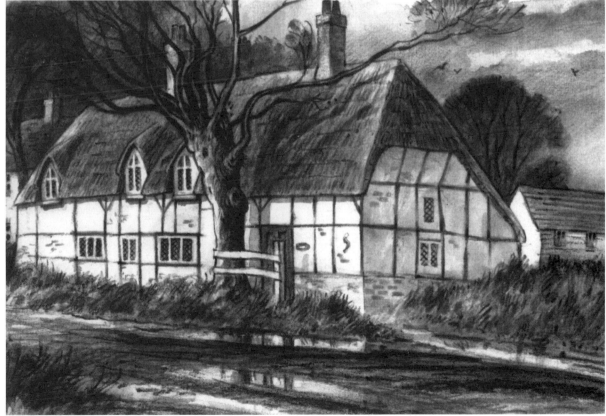

Ancient buildings

Old buildings offer rich areas of exploration. Apart from a study of architecture and the possible challenges of perspective there are usually opportunities to discover textures and small details which might be less obvious but more interesting to draw. Attempting to render surfaces with different media can also be very rewarding.

The freehand drawing on the right was done with a dip-in pen and without the use of a ruler, to give it character and avoid making it look too mechanical. A wax crayon was used as a resist to help create stone textures before an ink wash was applied. Small natural sponges dipped into paint or ink can also be effective.

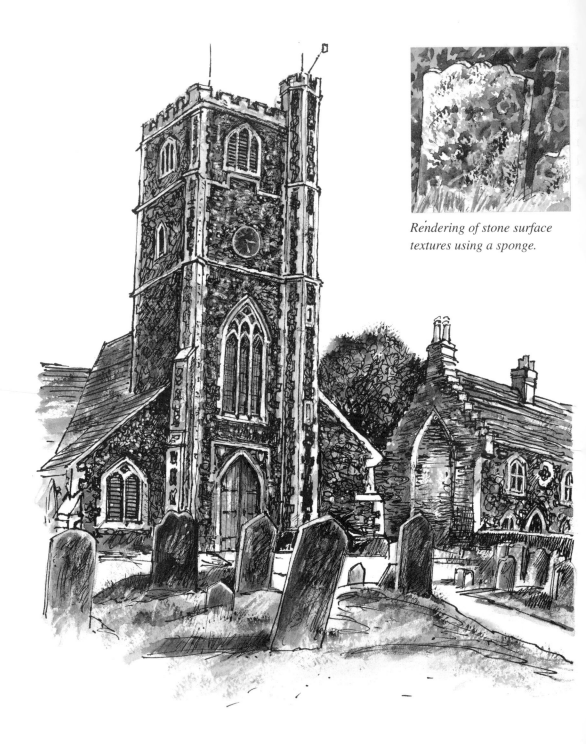

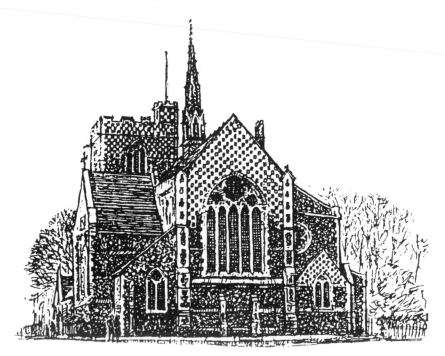

A line drawing for reproduction at different scales, using a technical pen.

Rendering of stone surface textures using a sponge.

The industrial landscape

In contrast to more conventionally picturesque rural landscapes, the marks of industry can make dramatic and fascinating subjects. A building site, quarry, power station or dock, for example, can be teeming with interest.

The sketch below was done standing up looking through a gap in the protective fencing surrounding a building site. A chill wind was blowing at the time and the discomfort definitely speeded up my pen.

It's a good idea to draw in the basic immovable components before adding figures and vehicles which come and go. This is now a local shopping centre and an example of recording 'history in the making'.

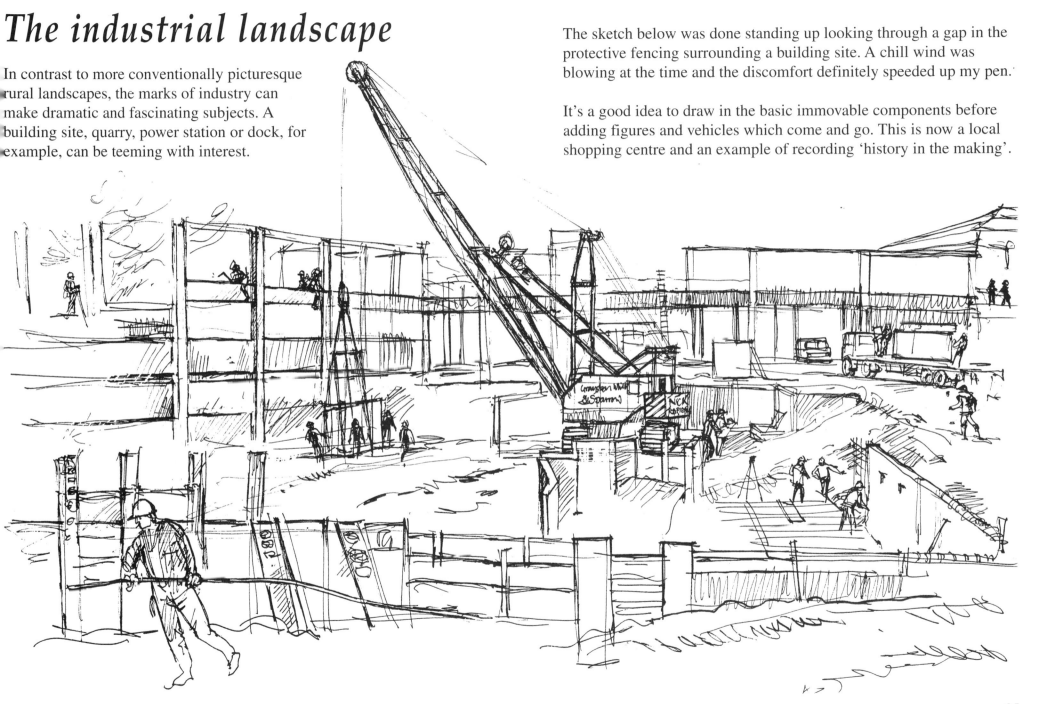

Farm buildings and equipment

Seldom pre-planned and usually built and maintained for purely functional purposes, collections of farm buildings are great to draw. Their strong shapes and structures, contrasting surface textures and materials all reflect constant changes of agricultural technology. Redundant equipment or derelict buildings are other favourite subjects and can create a ghost-town atmosphere, as the sketches on the next two pages show.

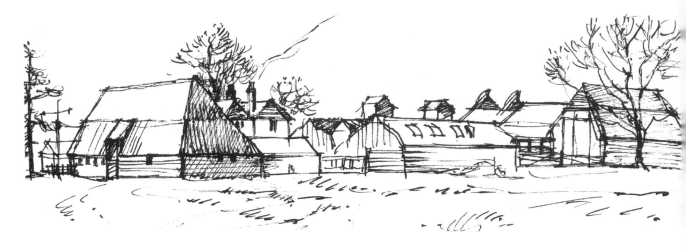

From a quick shorthand outline drawing such as this one above, it is possible to develop a more solid tonal rendering as shown below by establishing the direction of sunlight and emphasizing the contrasting shadows.

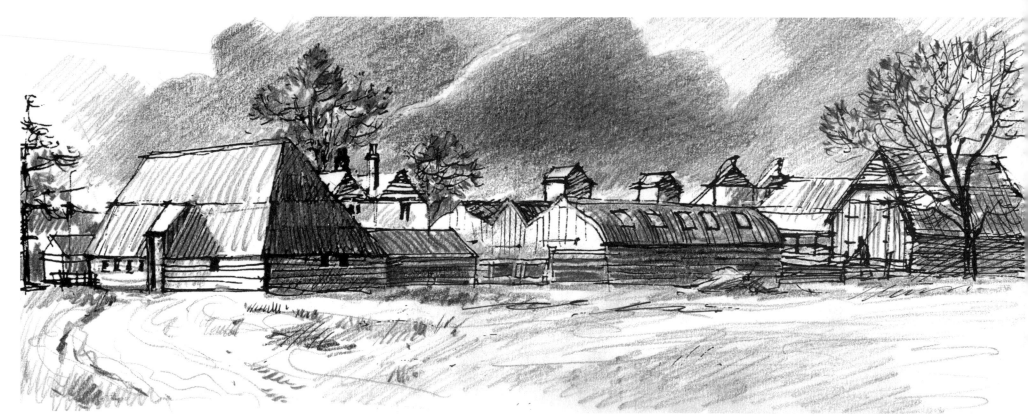

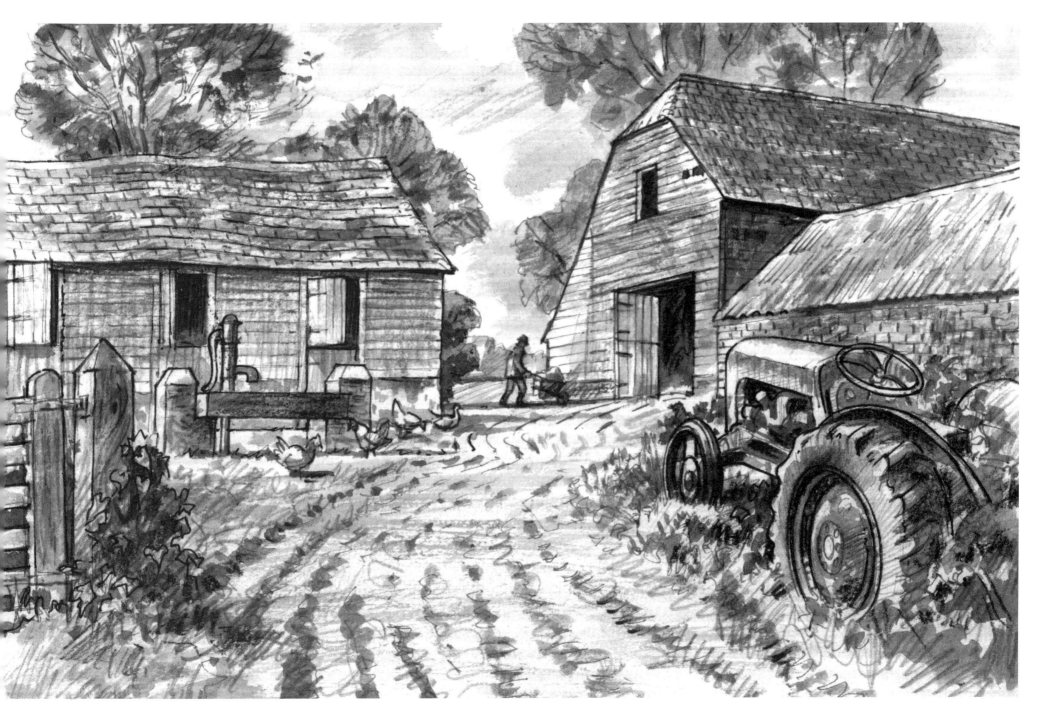

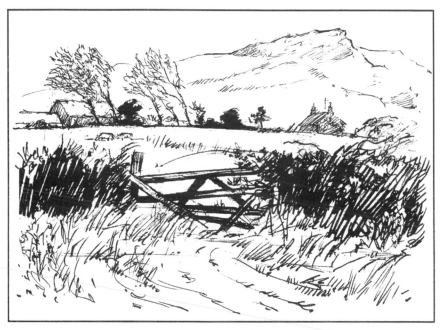

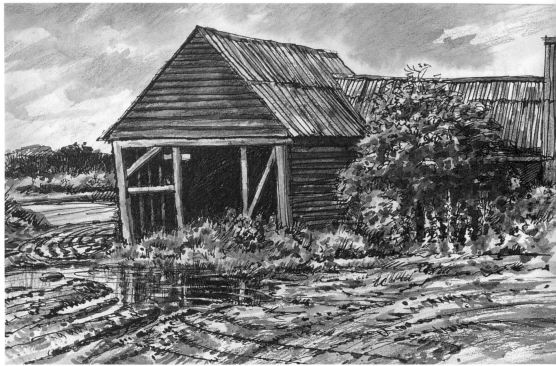

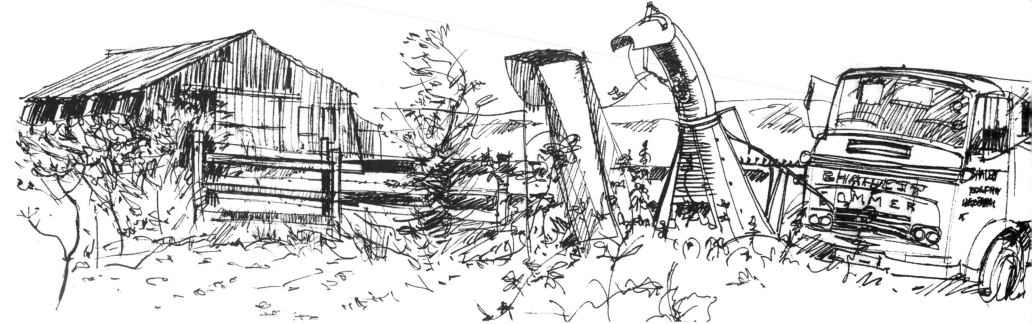

Fields, hedges, walls and gates

There's a great variety of subject matter to be found in this theme – an air of mystery about tunnels through overhanging branches leading to unknown vistas; weathered and worn old gates each with their own history.

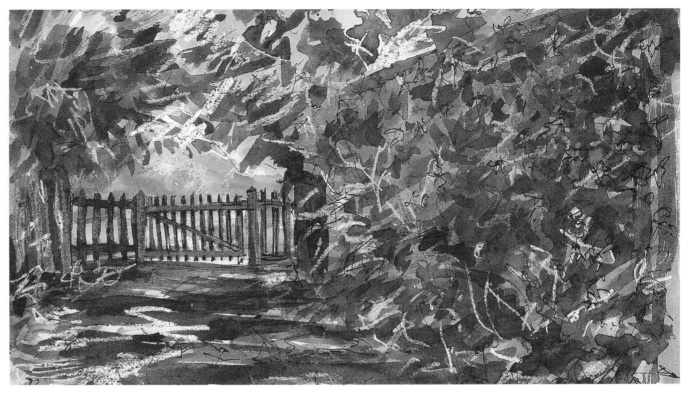

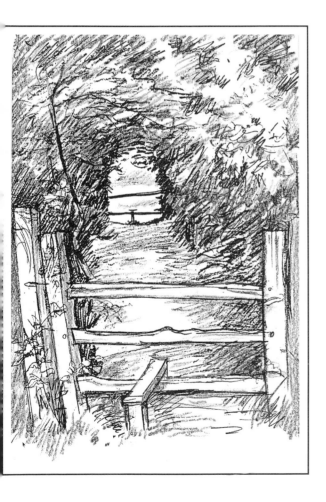

In the sketch above, I was experimenting using a white wax crayon as a resist so that highlights were created in the darker overlying watercolour washes.

It can be a bit fussy and difficult to control because once you put the wax on you are stuck with it even if you don't like the effect.

However, the best way of finding new treatments is to risk making mistakes.

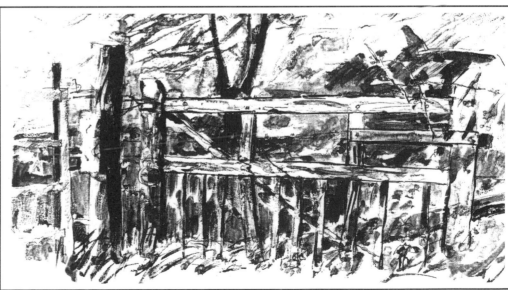

Country lanes

I'll admit a great affection for little, drunkenly winding lanes, away from the motorways. You never know what's round the bend, and if on foot you have a chance to hear the birds or the scurry of the odd fieldmouse or weasel in the undergrowth. Varieties of plants and insects, the changing seasons, passing joggers, people on horseback; all make walking a very different experience, and reveal a lot of things to sketch.

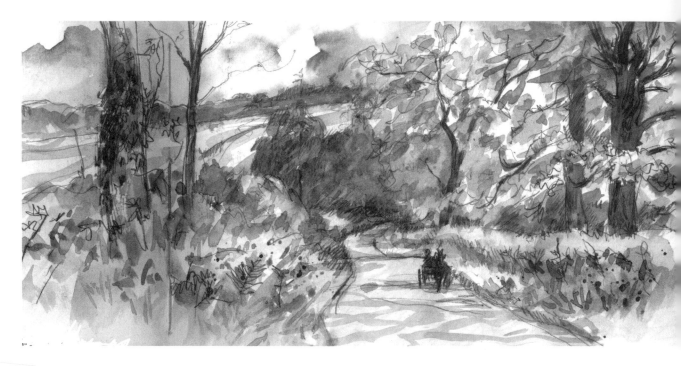

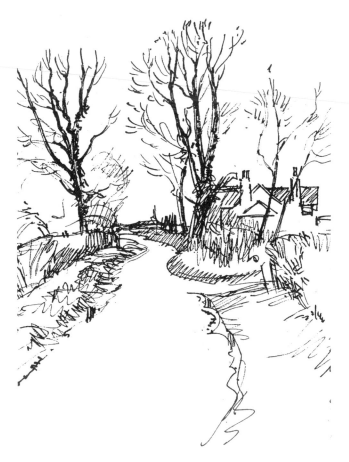

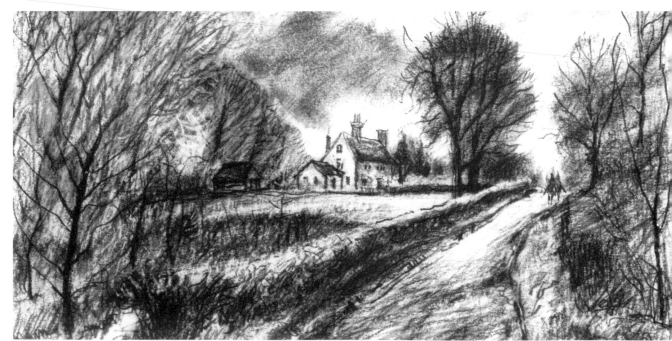

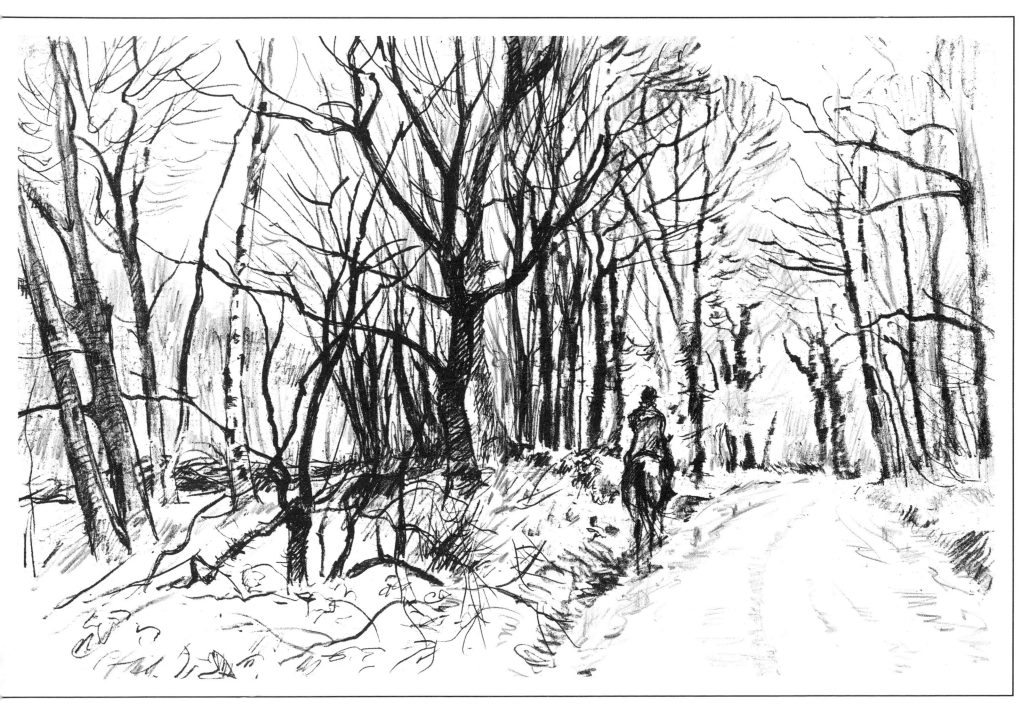

Seasons of the year

There are times of the year when working outdoors is a really pleasant occupation but weather conditions are not always favourable. Some of my sketches have been done in lay-bys, viewed through a car windscreen with rain or snow falling outside and a camera handy to capture fleeting breaks in the cloud. Despite the adverse conditions, the winter months are a good time to see the landscape stripped bare or simplified by snow.

The watercolour below was done using Chinese brushes which are very good for broad washes. With only a little paint or pigment on the brush, the hairs can also be split to produce interesting dry brushmarks.

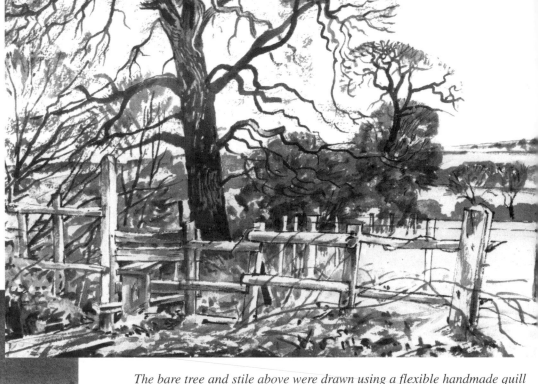

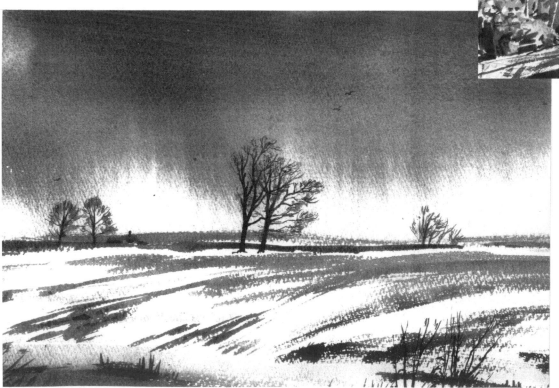

The bare tree and stile above were drawn using a flexible handmade quill pen, loaded with watercolour to give a sensitive line even on rough paper. Washes were then applied to fill in the larger areas of tone.

CUTTING A REED OR A QUILL PEN

 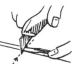 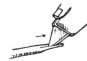

| *Make a long scoop cut at the end.* | *Shape the nib shoulders.* | *On a firm surface trim the end,* | *and make a little slit.* |

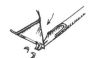

| *Pare down the inside to make it flat.* | *For a finer pen trim the upper edge of the nib.* | *Load with watercolour or ink; turn over to use.* |

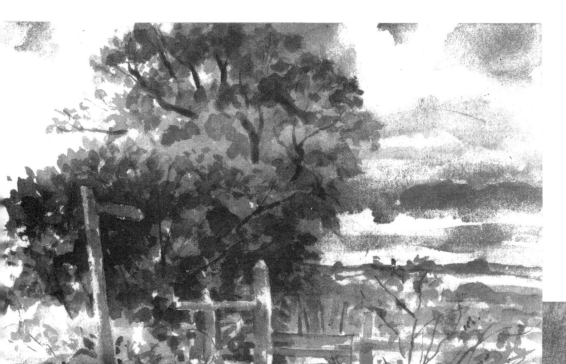

The same stile and tree as the previous page, but painted in summer, when lots of foliage and undergrowth make it hard to recognize as the same place. Here a brush has been used directly to lay simple washes, forming edges by the contrast in tones rather than relying on drawn outlines to define them.

Harvest time has been revolutionized by technology and although the fields are not perhaps as visually attractive as the haystacks painted by Monet, I keep telling myself to look for beauty in this present day and age rather than dwelling on nostalgia.

WORKING WITH A REED OR QUILL PEN

As an optional extra a reservoir can be added to your pen by cutting a thin slither of flexible plastic or metal. Bend it into an S shape and insert into the barrel of the nib a little short of the tip. The S shape holds the reservoir in place and should feed ink down more gradually rather than causing blots. You may remove it for cleaning purposes.

Loading the nib with a brush is more effective than dipping into an ink bottle and you can also use watercolour by scraping the nib across a brush held in your other hand. This enables you to draw fine lines and details in a watercolour with precision and to use pigments at different strengths.

Changing light and atmosphere

Changing lighting conditions radically alter the landscape by picking out some features or throwing others into obscurity. No matter how fast we work these effects can be quite fleeting and create very different moods. Sometimes a camera is the only way to capture them, or to return at the same time of day hoping for similar conditions, but there are times when we have to rely on visual memory.

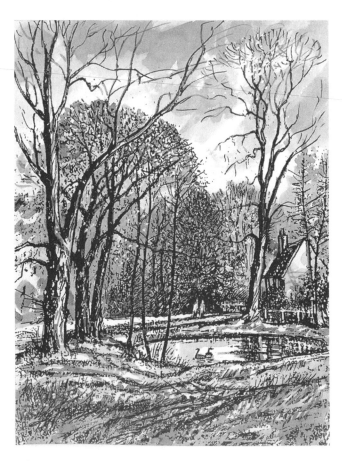

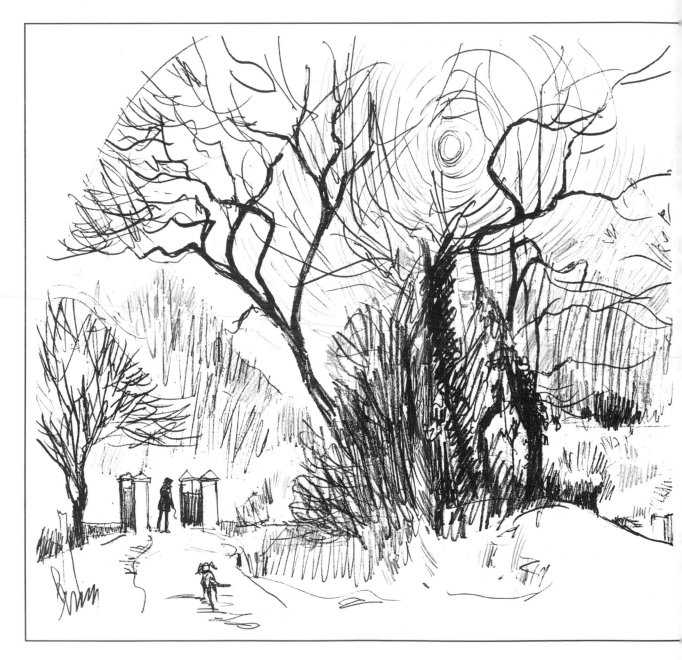

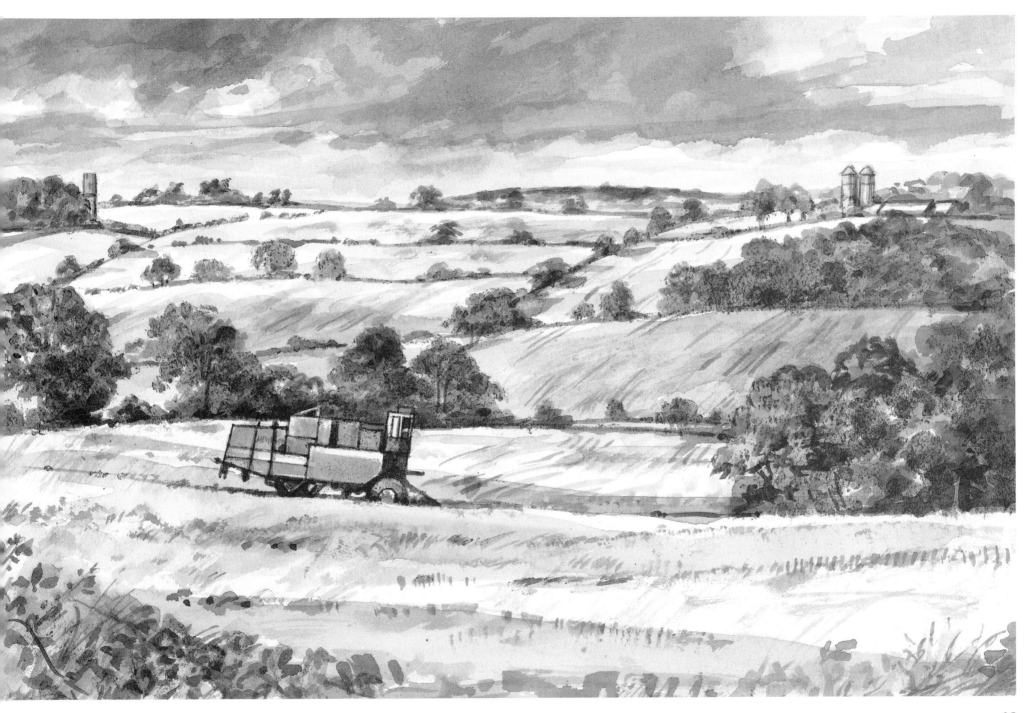

Sketching at speed

Drawing at speed obviously dictates the amount of detail and information that can be included. This is not always a disadvantage since it helps to develop a form of visual shorthand, rather like our personal handwriting, with excitement and energy in the marks.

Setting time limits and moving on to new situations is a good exercise in training the hand and eye to sum up essentials.

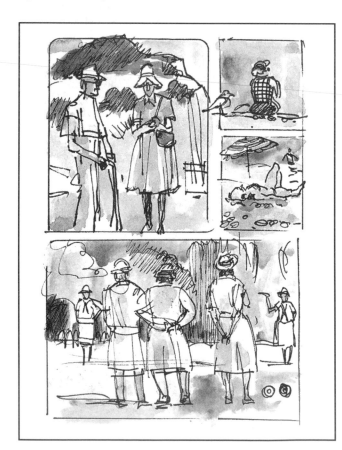

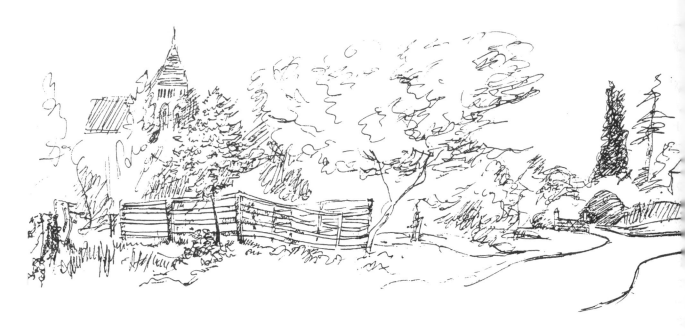

These sketches were done whilst standing up, using a fibre-tipped pen without any preliminary pencil drawing.

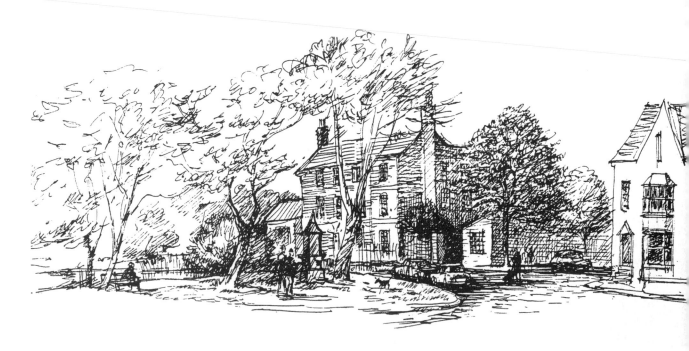

The camera as back-up

When sketching we focus our attention on visual qualities and open up our perceptions so that the whole act becomes a unique and memorable experience. Perhaps time or circumstances require us to move on before we finish the work or we want to continue or develop it elsewhere. A camera can be used as an extension to the sketchbook for gathering information.

Even with a wide-angle lens it may not be possible to include all that you would like in one shot, so several can be patched together to create a panorama. It is so much better working from your own photographic reference since it relates to your own perception and motivation rather than copying another's viewpoint.

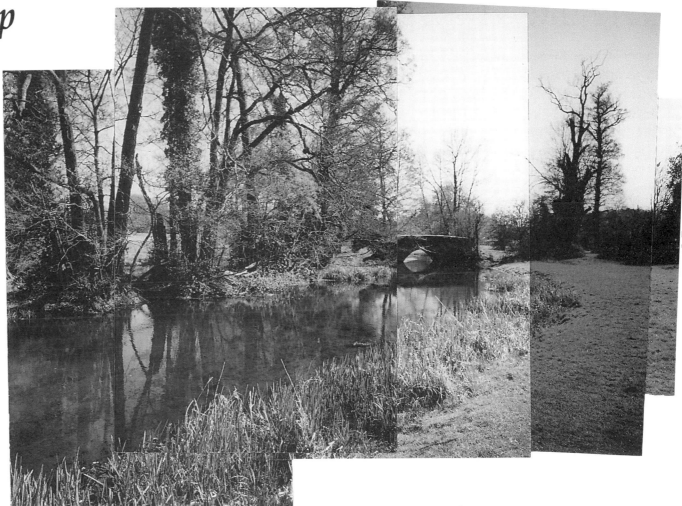

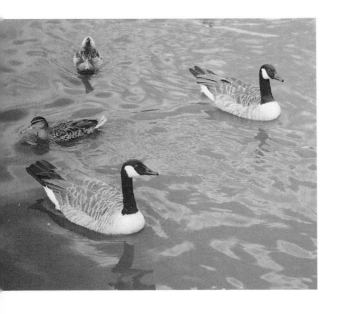

Close-ups of details such as plants or rocks, or transitory moving elements such as people or animals, can all be brought together to improve a composition. There is a value in compiling your own system of reference photographs which can be accessed when needed. Mine are kept in shoeboxes divided into categories such as 'skies', 'boats', 'wild flowers', or 'farm animals', for example, or vaguer notions such as 'textures' or 'light effects'. A collection like this soon grows and this rough and ready filing system at least saves me from having to scrabble through the whole collection every time I need inspiration or reference.

Travels with a sketchbook

It's more challenging than a camera but wonderfully satisfying to record your travelling experiences in a sketchbook. Try to be as inconspicuous as possible since people can be very curious or even resentful of this strange activity. A minimal kit of equipment which can fit into a pocket or a small bag is ideal. At times I pretend to be writing a postcard which tends to look a bit private and less likely to attract attention.

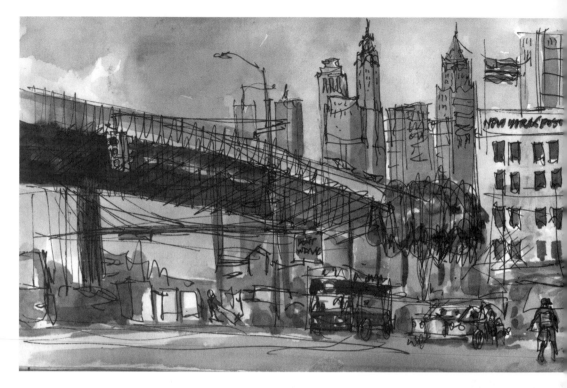

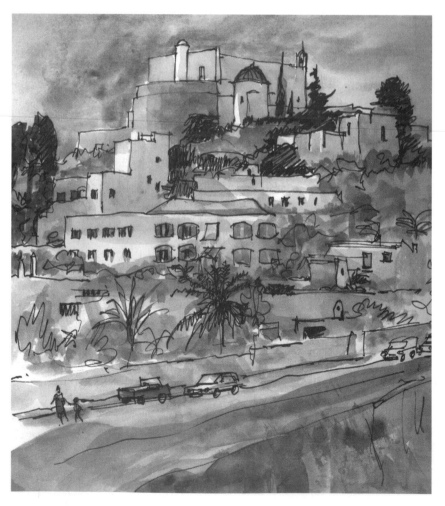

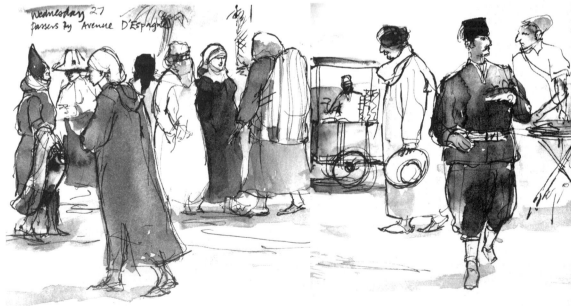

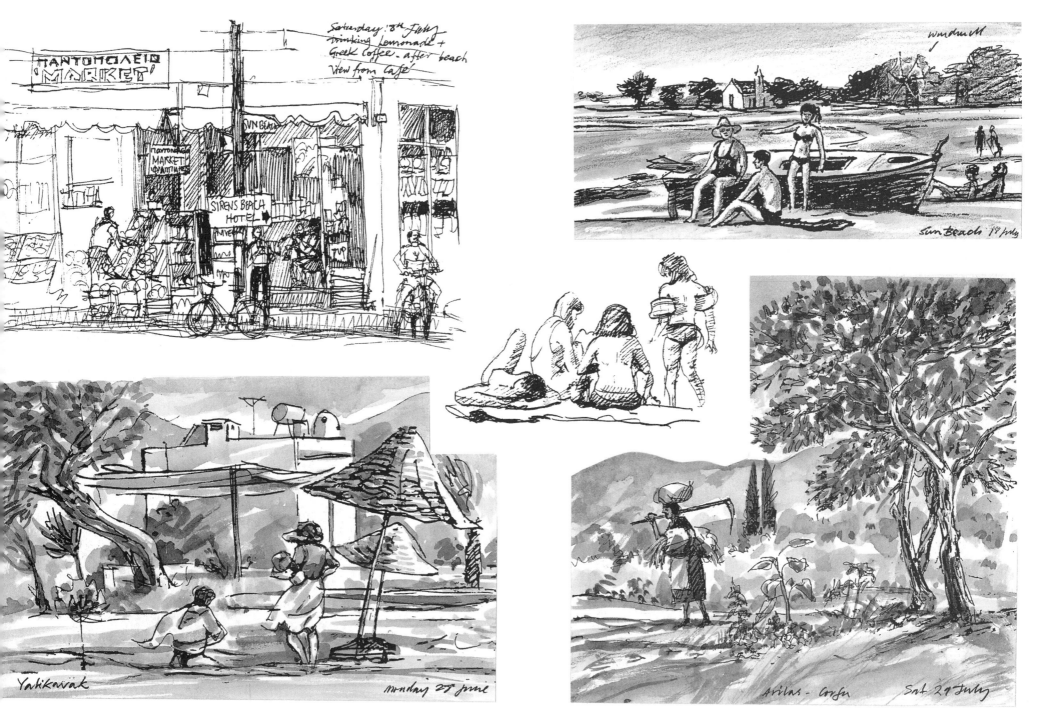

ΠΑΝΤΟΠΩΛΕΙΟ 'MARKET'

Saturday 18th July
Drinking Lemonade +
Greek Coffee - after beach
View from Café

Windmill

Sun Beach 19 July

Yalikavak

Monday 27 June

Avilas - Corfu

Sat 29 July

39

Composition

To draw things together in a pictorial composition we may incorporate images compiled from a variety of sources. Sketchbook drawings or photographs, for example, or magazine cuttings may just be helpful in triggering off a mood, a memory or an association, rather than being slavishly copied.

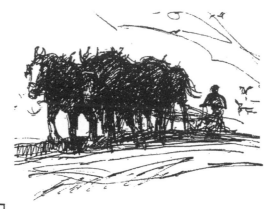

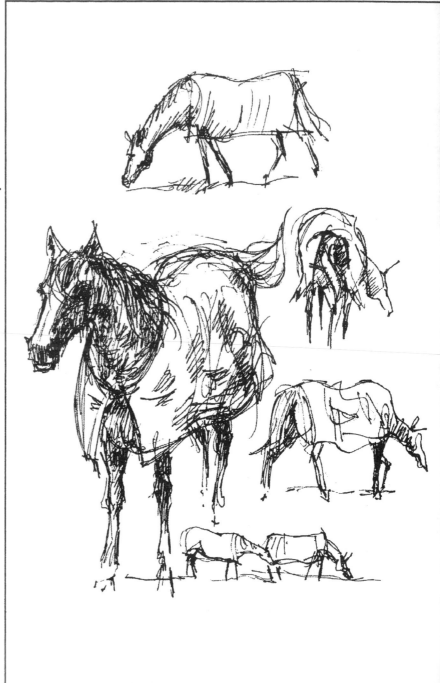

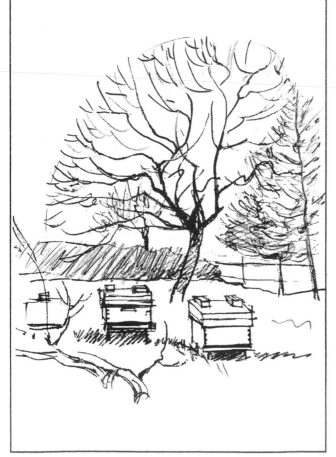

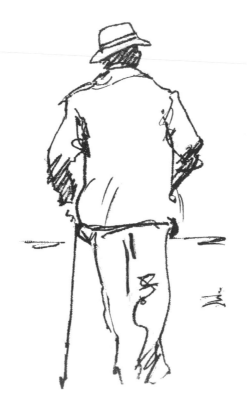

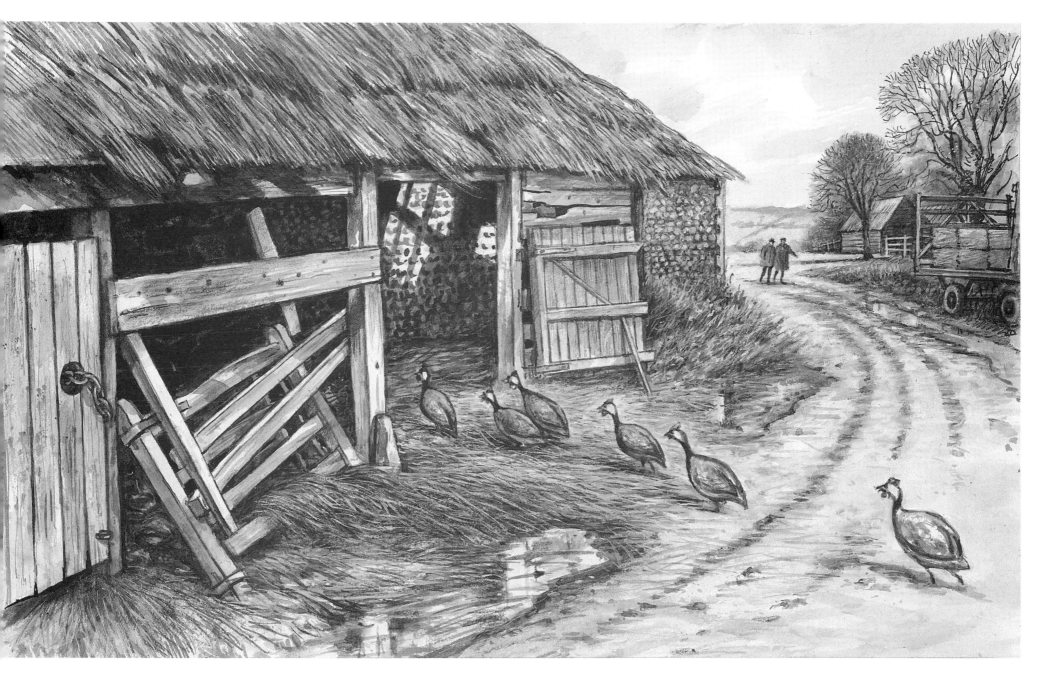

This composition was put together from several sources. The guinea fowl were from separate photographs taken in the same location as the old barn; the background and figures were then added from imagination.

Pictorial composition involves control and manipulation of elements within a design area. We may try to do this in a sketch by adjusting the viewpoint, moving something or even leaving it out (something a photograph can't do). Below are some useful principles.

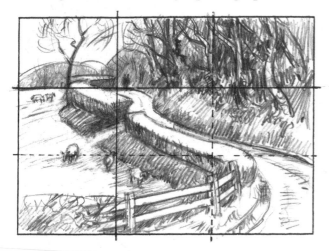

Compositions can be organized according to 'the rule of thirds', by which imaginary lines divide the picture area into thirds both horizontally and vertically. Strong elements can coincide with these lines.

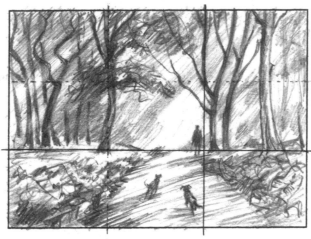

It is helpful to try out some simple thumbnail sketches like these illustrated, where the arrangement of major forms to be included is explored and adjusted before embarking on a full-scale layout.

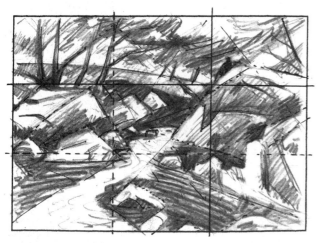

The principle of balancing overlapping areas, forms and contours is the basis of all pictorial creation. Since line is our first means of defining these, then linear arrangement becomes our first consideration.

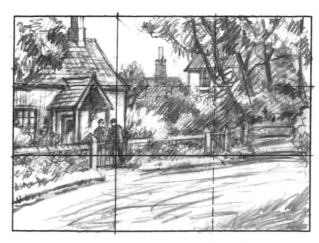

Every good picture should have a main focal point. All lines should draw the eye towards that spot and an imaginary horizontal and vertical should cross at the main point of interest within the composition.

The sketch below has some strong diagonals made by the structure of the gate, leading the eye towards the small cart which was the focal point. This was done on the spot but follows the 'rule of thirds' quite instinctively.

Many successful compositions can be based on simple implied geometrical shapes such as triangles or circles.

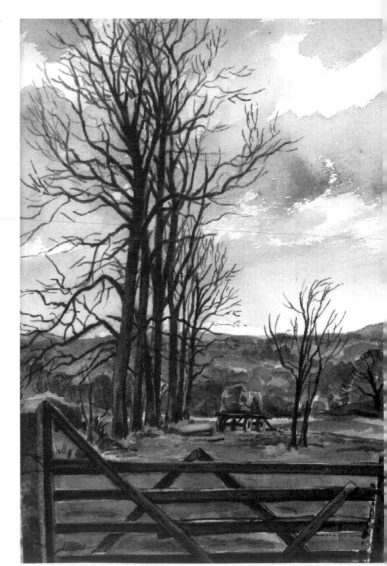

42

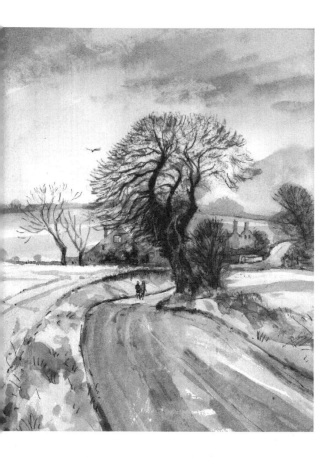

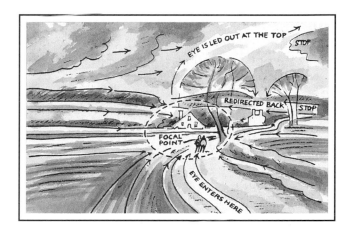

In every good picture there should be a planned easy and natural path for the eye to travel. You can make the eye follow a given course by use of line. Lead the eye in, entertain it with a spot of interest and then allow it to pass out of the composition. It should be a pleasing path and not obstructed or given two ways to go. The eye should enter at the bottom and emerge at the top rather than at the sides. Lines leading out of the subject should be stopped by some device or another line leading back to the focal point.

The sketch above was done looking through a car windscreen on a chilly afternoon. It becomes a challenge to find a good parking space with a view that doesn't obstruct passing traffic!

The painting on the right is based on this sketch but with a change of format from vertical to horizontal. To attempt to make it look like one of the early railway posters which first inspired me to take up landscape painting I have used opaque poster paints. These allow tones to be overpainted and rendered in a simplified, flat manner.

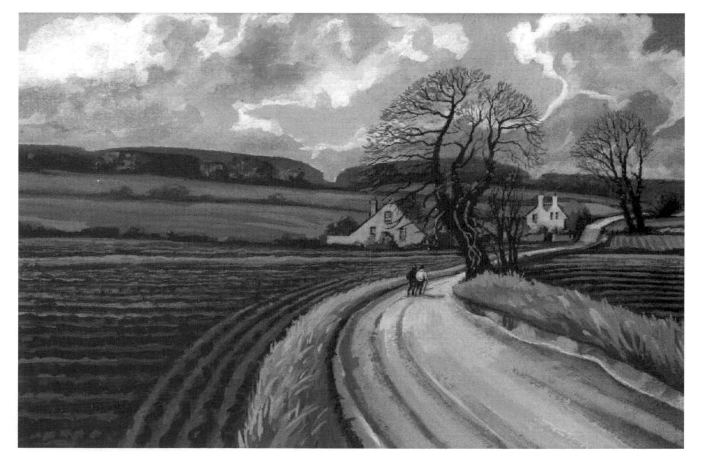

Landscapes with figures

Paintings without people in them can seem to lack interest; when they are included a sort of empathy enables us in some way to enter the picture. Figures can therefore act as potent elements within a pictorial composition.

A consideration of composition is essential to successful painting. Without a good underlying structure the whole thing can fail to hang together, and no clever technique or style can save it. Good composition involves the careful placing of, and fitting together of, all the elements in the picture. If we study and analyse the work of many past and contemporary painters, we can observe how carefully their work has been composed. Try laying a piece of tracing paper over a postcard or reproduction, and then trace the major subdivisions and lines of sight which the artist has used. Notice how, in some, the placing of a figure or group of figures, animals or human artefacts has been used to good effect. Imagine what the picture would have been like without them.

It is sometimes not necessary to make figures too sharply defined or identifiable. They can be simply strategically placed blobs of paint, shapes, flicks of colour; more like impressions of a presence than a detailed description of a male or female figure wearing any specific type of clothing or performing any particular function. This is most appropriate when the rest of the painting is equally simplified.

However, when we move to more detailed paintings other factors have to be considered, such as perspective, gesture and shape. And what are the figures doing? Age, gender and clothing, as well as interrelationships and accessories, have to be described. These are not easy to suggest without observation, experience and practice. This is again where keeping, and constantly using, a sketchbook is particularly vital to the figurative artist.

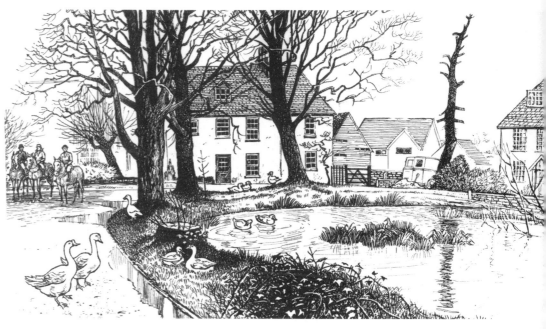

The above pen line drawing intended for reproduction in a magazine includes ducks, geese and figures on horseback added to compile an impression of a particular location.

You can 'hang' your figures on the horizon line by making it cut through similar figures in the same place. This keeps them on the same ground plane.

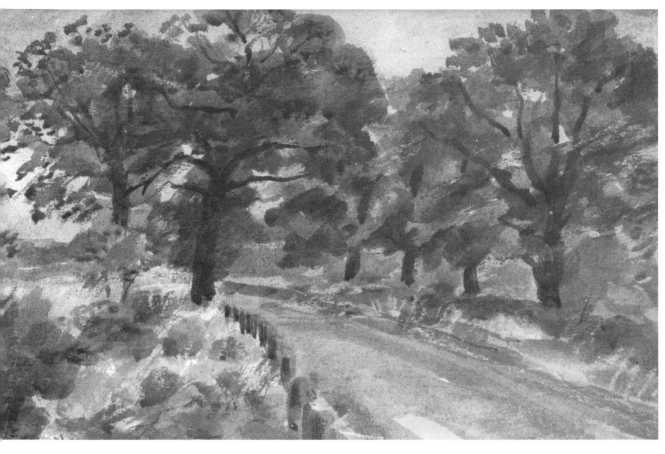

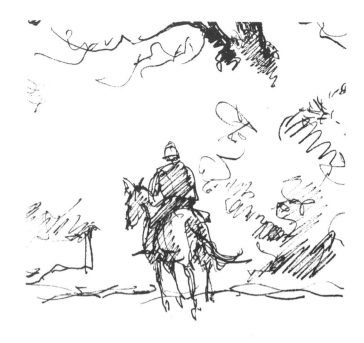

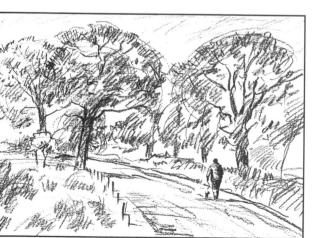

The wash and crayon sketch above could be developed into a composition with added human interest by perhaps including someone walking a dog, wheeling a bicycle or riding a horse, like these examples found in some of my other sketchbooks. The thumbnail layout on the left shows how a figure could fit into the composition.

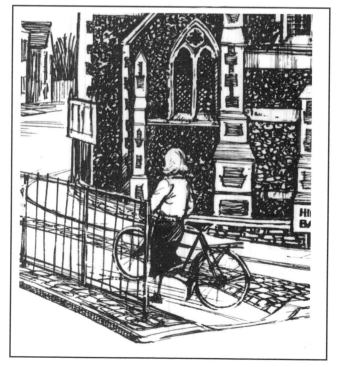

Composing a picture

This page demonstrates how to assemble a composition from a variety of sources.

The pen sketch on the right has some written comments to point out important features and notes to assist in the use of colour if it is going to be used at a later stage.

To back this up I took various panoramic photographs, including trees to the right of the road which threw long shadows at a certain time of the afternoon.

I searched for some possible human interest to introduce and did thumbnail layouts to find a suitable location within the composition, which appears in its final form on the opposite page.

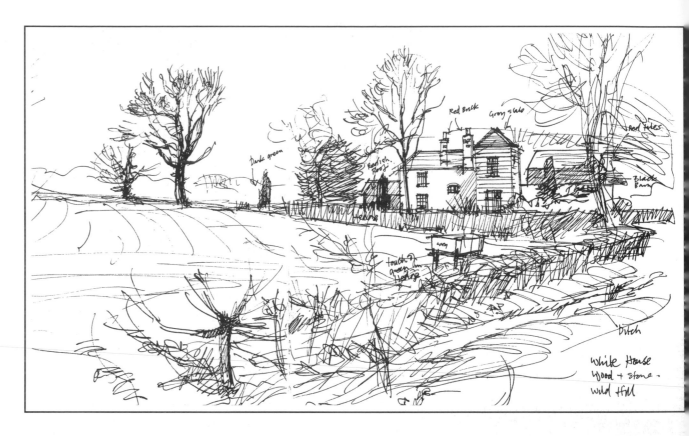

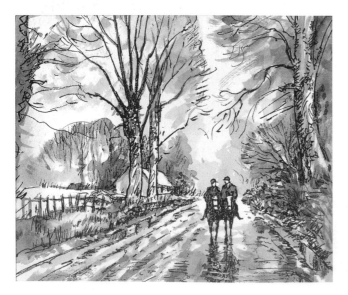

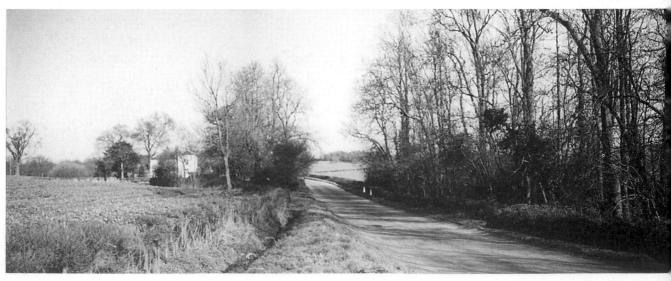

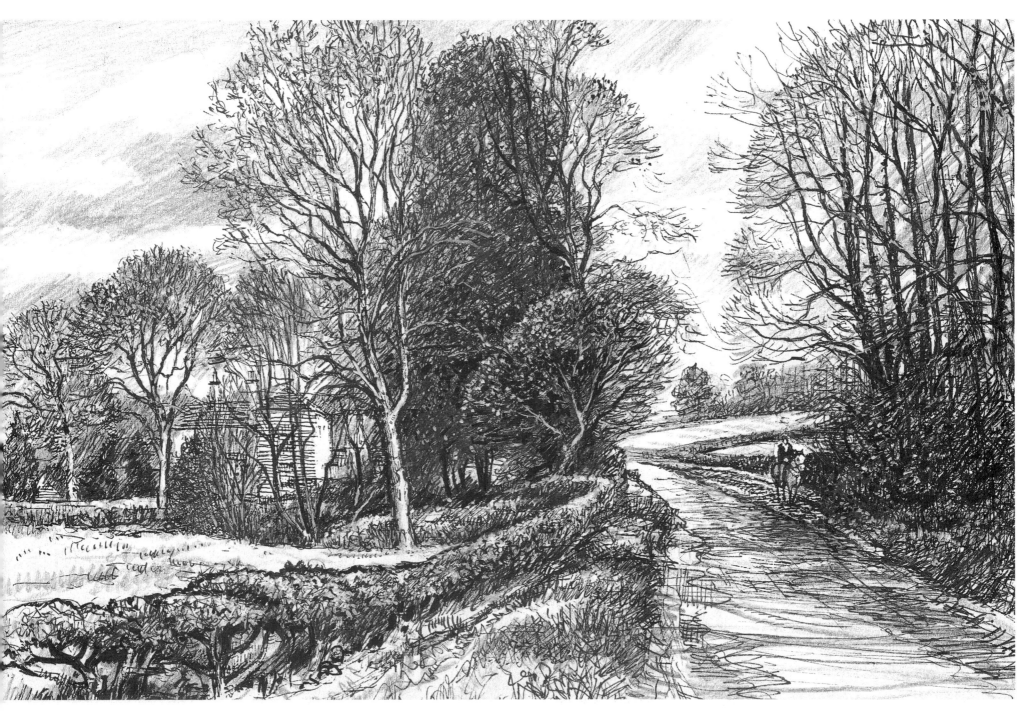

To sum up

Exploring the visual world through sketching and drawing is a very rewarding activity and I hope that the approaches briefly covered in this book will encourage you to go out and experience this for yourself.

• Keeping a sketchbook or a visual diary should be a personal, rather private and uninhibited activity which will enhance your life awareness.

• You don't need to rush out and spend a lot of money on equipment, because the simplest tools are best to start with.

• Choose the right paper surface for the medium you are going to use. The size and format of your sketchbook should be convenient and reflect your personality.

• It isn't necessary to go far afield to find interesting subject matter for a drawing.

• Problems with perspective shouldn't become a barrier. They will be overcome with experience.

• Look out for simple tones and shapes before getting down to details.

• Sketching at speed is a good way of developing your own personal style and visual shorthand. However, a camera is a useful back-up to help overcome the problems of changing light, atmosphere and circumstance.

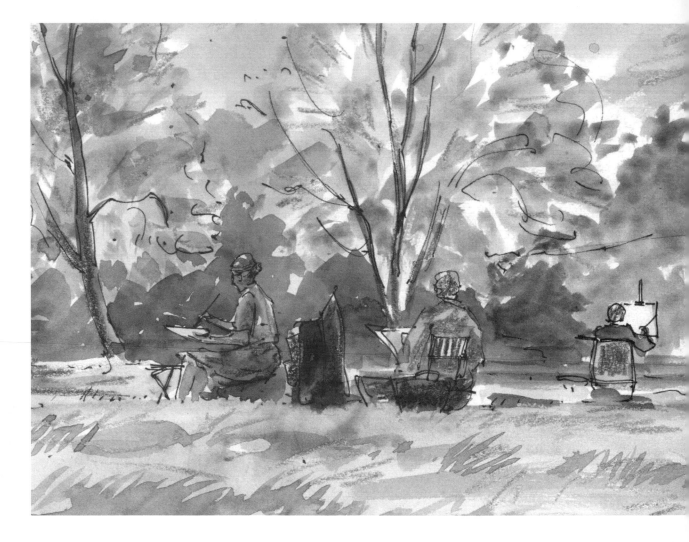

• Travelling with a sketchbook has its difficulties but it provides a very personal and lasting memento of your experiences.

• Keeping a sketchbook can be an end in itself but it can also be a means of collecting reference information or doing trial thumbnail layouts to organize a pictorial composition.

• A variety of visual sources can be used when compiling a picture and care must be taken to lead the eye to a major focal point.

• Bear in mind that including human interest can make a picture more accessible to the viewer.

Good luck!